IMAGES
*of America*

# MASON COUNTY

IMAGES
*of America*

# MASON COUNTY

Jason Bolte on behalf of the Mason
County Convention and Visitors Bureau

ARCADIA
PUBLISHING

Published by Arcadia Publishing
Charleston SC, Chicago IL, Portsmouth NH, San Francisco CA

Printed in the United States of America

Library of Congress Control Number: 2009932159

For all general information contact Arcadia Publishing at:
Telephone 843-853-2070
Fax 843-853-0044
E-mail sales@arcadiapublishing.com
For customer service and orders:
Toll-Free 1-888-313-2665

Visit us on the Internet at www.arcadiapublishing.com

To the people of Mason County.
This is your story. Thank you for everything.
And to the loving memory of Marsha Smith.
Thank you.

# CONTENTS

# ACKNOWLEDGMENTS

I would like to thank everyone who provided me pictures, guidance, or information during the creation of this book. Writing a book about West Virginia while living in Atlanta is not the easiest task in the world, but the individuals and organizations that aided me along the way eased the stress and removed many of the logistical roadblocks of an endeavor such as this one.

With the deepest of gratitude, I would like to thank Carolyn Sommer Costen Hartenbach, Catherine Yauger, Jack McCoy, Keith Sayre, Marsha Powell, Randall Kenton Shelines, and Scotty Hill for their assistance. I met many of you for the first time, and it was an absolute pleasure. I would like to thank the Point Pleasant River Museum and the West Virginia State Farm Museum for allowing me access to their records and collections. I would also like to thank Jeff Wamsley and the Mothman Museum for keeping the stories and tales alive that are rarely found in print.

My deepest gratitude goes out to Rod Brand, Juanita Burdette, and Natalie Morgan. This is the second book that Rod has graciously helped me with, and he is always the first person I turn to for information. Natalie and Juanita, the Queens of Leon, are wonderful women with more information in them than I can ever hope for. Thank you so much for the pictures and for coming to my rescue on short notice.

I must also thank Bo and Hunter Bellamy, Marsha Smith, Joanne Lerner, Ash Minnick, Caroline Harris, Roger and Twila Clark, and Denny Bellamy. You volunteered your time to help me with this book, and I am eternally grateful for that. I hope to return the favor someday.

And finally, I would like to thank Mike Brown, Bob Keathley, and Karen Fridley. Mike and Karen continue to help me immensely again and again. I must thank Bob for his collection and for allowing me to access it. He showed up at a time when I thought all was lost, and he single-handedly saved this book. Thank you. And thanks to everyone I forgot to mention.

# INTRODUCTION

The story of Mason County, much like the story of the United States of America, begins with George Washington. As a reward for their service in the French and Indian War, a group of veteran officers received a large land grant in the western part of the Virginia Colony. The grant was offered directly from the King of England, and George Washington was among the men hired to survey the land for the king. In the fall of 1770, George Washington and his men arrived at the confluence of the Ohio and Kanawha Rivers and conducted their survey for the grant, which consisted of the land below the Kanawha River and up to the Ohio River at Letart Falls.

Nine veteran officers were included in the land grant comprising Mason County: Andrew Lewis, George Muse, Peter Hog, Andrew Waggener, John Polson, John West, Hugh Mercer, and George Washington. Some of these men settled into the area and established themselves on the land. George Washington, having received 10,900 acres on the south side of the Kanawha River, attempted to establish a settlement in this area, though the eruption of the American Revolution interrupted these plans.

Andrew Lewis's grant consisted of the land around the confluence of the Ohio and Kanawha Rivers, known by the Native Americans as Tu-Endie-Wei, or "where the waters mingle." Four years after the fulfillment of this land grant, Andrew Lewis would return to this area in the Battle of Point Pleasant. Leading a Virginia militia against a coalition of Native American tribes led by Chief Cornstalk, Lewis led his forces to victory on his own land. This battle was the turning point in the ill-fated Lord Dunmore's War; Lord Dunmore was the governor of Virginia who presided over the land grant from the King of England.

Mason County was incorporated into the General Assembly of Virginia in 1804. The land comprising Mason County was originally part of Kanawha County, though a petition led by Capt. William Clendenin to the General Assembly of Virginia led to the formation of this new county. Upon its creation, Mason County was granted 904 square miles. The county is named after George Mason, a Virginia statesman and founding father of the United States.

Early visitors to Mason County included Daniel Boone, who, after incurring trouble in his home state of Kentucky, moved to the Mason County area. Boone established a trading post along the Kanawha River, and he and his family lived in the area for a few years. Another early visitor was Samuel B. Clemens, grandfather to Mark Twain. Clemens brought his family, including Twain's father, John, to Mason County shortly after its incorporation, though he died a year later, in 1805.

Throughout much of the 19th century, the various cities, towns, villages, and communities emerged throughout Mason County. Point Pleasant, though it had been in existence in one form or another since 1774, became Mason County's seat when the county was incorporated in 1804. In the northern part of the county, known as the River Bend area, coal and salt mining towns sprang up around the middle of the century. Cities such as Mason, created in 1852, and New Haven, established in 1858, formed out of the growing demand for salt and coal in the regional

and national economy. By the end of the century, this area hosted some of the biggest cities in the county, as well as some of the most prosperous. Mining companies and salt furnaces littered the River Bend, and corporation towns such as Hartford added their industry to the burgeoning economy. By the dawn of the 20th century, and particularly by the start of World War I, this area began its steady decline, the demand for salt and coal decreasing and, with it, the population of the area.

The Kanawha River towns are a different story, however. Created, as they were, later in the history of Mason County, these small river towns never experienced the bustle and boom that intensive industry harbors. Rather, river communities such as Leon, incorporated in 1872, and Southside, formally established around 1880, were relative newcomers to Mason County by the time of the big population boom. Over the years, these town have managed to remain relatively steady in their size and growth.

Regardless of its location in the county, every city is in some way tied to the two rivers: the Ohio and the Kanawha. George Washington and his surveying team navigated the county by these rivers, and it was their layout that determined much of the positioning of the king's original land grant. The Battle of Point Pleasant took place at the confluence of these rivers, and it was there that Chief Cornstalk was murdered at Fort Randolph a few years after the battle.

The rivers play a more central role in the evolution of the county's cities, however. The coal and salt industry in the northern part of the county was dependent on readily accessible waterways, and much of the salt was processed using water from the Ohio River. Shipbuilding companies emerged in every corner of the county, from tiny shipyards in Leon, Letart, Mason, and New Haven to massive complexes such as the Marietta Manufacturing Company in the Heights district of Point Pleasant.

Conversely, every town along the river experienced some hardship from the rivers. The Ohio and Kanawha Rivers encountered heavy flooding on an almost yearly basis from 1880 until 1940. The most devastating floods poured through Mason County in 1913 and 1937, leaving every town near the riverbanks underwater for days. Other disasters abounded on the rivers, including the Silver Bridge disaster in 1967, when the Silver Bridge collapsed into the Ohio River near Point Pleasant. Forty-seven people died in the water that day, an infamous moment in the county's history.

Mason County is a land hewn from history, its indelible features permeating every hill, valley, stream, and riverbank. The towns, villages, and communities that pepper the landscape are unique in their own right and disparate in their separate regions of the county. This county is a land formed from the earth and the waters around it, from the people inhabiting it, and from the history that consumes it. Mason County is a county of personalities and distinctions, an inimitable region as bounteous as the rivers around it, located at the mingling waters of history, people, culture, and geography.

# One

# TWO RIVERS RUN

The structure of Mason County is comprised of water, a liquid, flowing current of creek beds, streams, and mighty rivers through which the livelihood and essence of the county's denizens exist. The waterways are the heart and body of Mason County, the system sustaining and enriching life throughout the various towns, villages, cities, and communities. Through flowing water, the county comes alive, and from the water was the county truly born.

On the northwestern edge of Mason County flows the Ohio River, the nation's first true highway and the borderline between the north and south United States. The earliest towns of Mason County sprang up from this waterway, and the Ohio River brought the first settlers to this land. All the streams of Mason County flow into the Ohio River, feeding it as the river continues its journey west into the nation's heartland.

The towns of the Ohio River in Mason County are creatures born from their connection to its flowing waters, river towns feasting on the fertility and opportunity that surges out from the river's depths and into the surrounding landscape. Communities such as Point Pleasant, Henderson, and Letart were founded because of the river's ease of access. Industry and economy blossomed under the river's nurturing touch. Other towns, such as Mason, New Haven, and Hartford, used the river as a supplement to the resources around it, a support network constantly surrounding their focused perspectives.

The Kanawha River bisects the Ohio River in Mason County. Flowing into the Ohio River, this corollary continues the river tradition, albeit at a much smaller pace and scale. Where the largest towns of Mason County can be found along the Ohio River, some of the smallest ones are situated on the banks of the Kanawha. Nevertheless, these towns, such as Leon, Ambrosia, and Arbuckle, mimic their greater brethren, using the river as their guide.

Just as the rivers can give and nurture, so too can they take away and destroy. Though a town creates riverboats or coal barges to use on the river, a flood may come and engorge the community entirely. Though a bridge may be built to overcome the river, it may also collapse into the river again. Thus this chapter is about the complicated relationship between river and community, between Mason County's towns and the whims of nature around them, and about the ongoing communication between those two worlds.

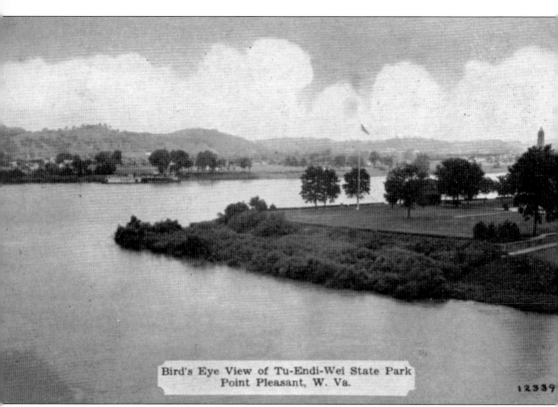

Bird's Eye View of Tu-Endi-Wei State Park
Point Pleasant, W. Va.

12339

The confluence of the Ohio and Kanawha Rivers is known as Tu-Endie-Wei, a Wyandot word meaning "where the waters mingle." The convergence of these rivers is one of the major geographical features of Mason County. The Ohio River, the first American highway, brought river traffic from both the East Coast and the emerging Midwest through the small river communities that dotted the banks. The Kanawha River brought coal and other industry from deeper into the heart of West Virginia. Before any major river traffic, though, this area played host to the Battle of Point Pleasant, a major battle in the short-lived Lord Dunmore's War. In 1909, a monument was erected in commemoration of this battle. The city of Point Pleasant grew from this site, eventually becoming the largest city in Mason County. (Courtesy of Mike Brown.)

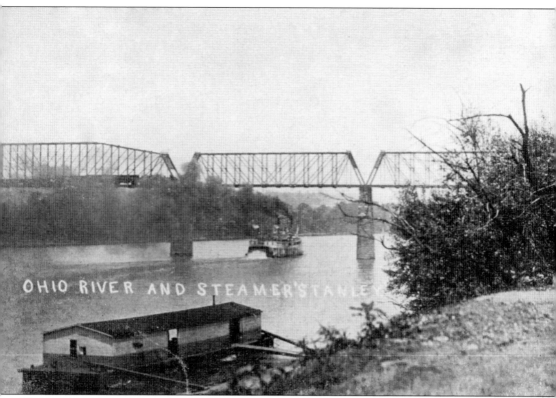

OHIO RIVER AND STEAMER STANLEY

This image, taken in 1909, depicts a common scene on the Ohio River across Mason County. From the Colonial era through the middle of the 20th century, the Ohio River was populated with water traffic of all types, from steamboats to packet boats and towboats to shanty boats. Mason County, and particularly Point Pleasant, was a major stop along the river, especially in the Cincinnati-Pittsburgh commercial route. Much of the industry in Mason County was devoted to the river business, from ship-building operations like the Marietta Manufacturing Company to coal barges and power plants and other industries sprouting up for easier access to the river's transportation channels. In the northern part of the county, the salt works and coal mines were as tied to the river as any other aspect of the county. The Ohio River was the artery of the county, a means of connecting its people to the rest of the country as well as spreading the county's culture beyond its modest borders. (Courtesy of Mike Brown.)

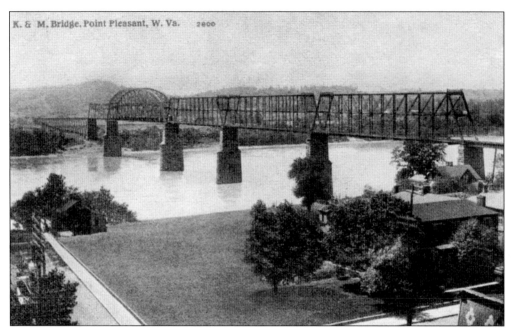

K. & M. Bridge, Point Pleasant, W. Va.   2600

Taken at the early part of the 20th century, this picture portrays Sixth Street of Point Pleasant before the construction of the Silver Bridge. The Kanawha and Michigan Railroad was built in 1918. Until the middle of the 20th century, the K&M Railroad served as a passenger rail through the Kanawha River valley. (Courtesy of Mike Brown.)

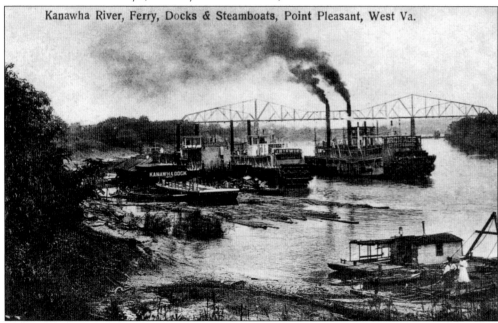

The Kanawha River is West Virginia's largest inland waterway, with over 90 miles of navigable water, all of which lies within the state's borders. The Kanawha River flows northwest into the Ohio River, providing traffic from the state's capital, Charleston. Though not as long as the Ohio River, it still maintained an impressive amount of river traffic, particularly the coal barges and towboats from the mines deep within West Virginia. (Courtesy of Mike Brown.)

Before 1928, the only means of crossing the Ohio River in Mason County was by ferryboat. The *Ann Bailey* (below) was the ferryboat in operation between Point Pleasant, West Virginia, and Gallipolis, Ohio, from 1901 until 1928. Captain McDade was the last captain of the ferry. With the growing popularity of the automobile, river ferries became less convenient. Two bridges sprang up on the Ohio River, one near Point Pleasant and one near Mason, turning the ferryboat into a thing of the past. Passenger rail faced a similar fate, as the Ohio River Bridge (above), once built for the K&M Railroad, slowly phased out its passenger rail routes. (Both courtesy of Mike Brown.)

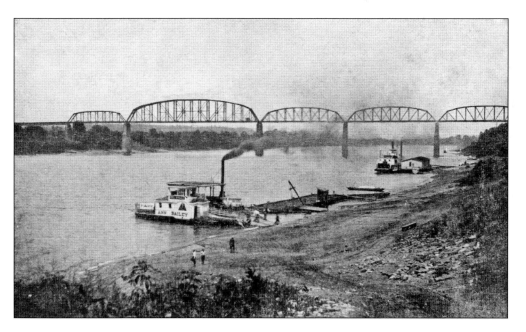

13

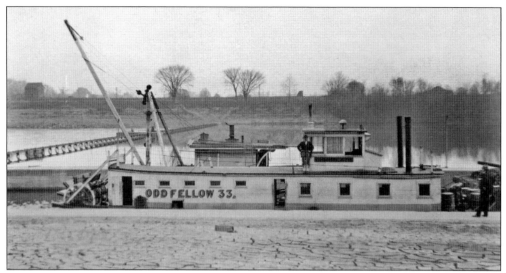

This towboat was named after the local chapter of the Odd Fellows, an international fraternity group. In the Point Pleasant area, the Odd Fellows Lodge 33 has existed for decades, serving as one of the largest fraternity organizations in the county. This towboat operated along the Ohio and Kanawha Rivers. The man standing on the top of the boat is Hamp Smith. (Courtesy of Odd Fellows Lodge 33.)

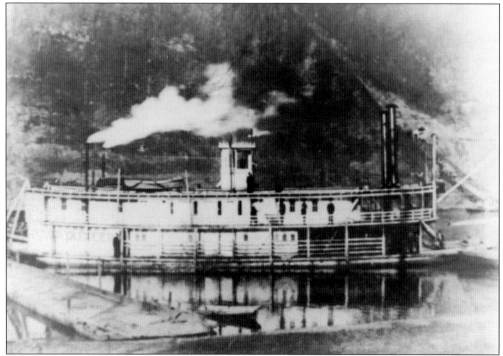

The Kanawha River packet boat *Mountaineer* was built around 1890. The owners of the boat were George Stone and William Stone from the Point Pleasant area. Members of the Stone family could be found throughout the area's waterways. George Stone is the great-uncle of Capt. Charles Henry Stone, a former riverboat captain and ferryboat operator. (Courtesy of Point Pleasant River Museum.)

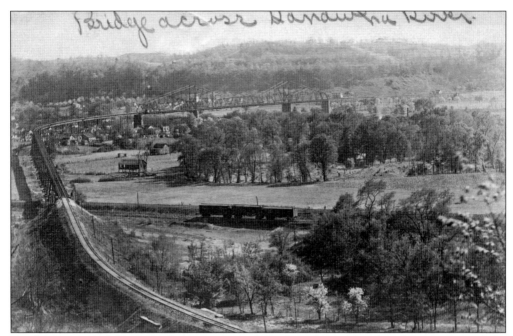

Two bridges crossed the Kanawha River, one built for the railways (above) and one for automobiles (below). The Baltimore and Ohio Railroad (B&O) traveled north to the towns of Mason, New Haven, and Hartford, unlike the K&M Railroad, which crossed the Ohio River and followed the Kanawha. The Shadle Bridge, built in 1930 and 1931 by the Holmes Construction Company, was used primarily for automobile traffic. Until 1945, the bridge was a toll bridge. The Shadle Bridge was destroyed in 1998 after nearly 70 years of operation. Though considered outdated by the time it was demolished, the Shadle Bridge served a very prominent purpose during many years in service. (Both courtesy of Bob Keathley.)

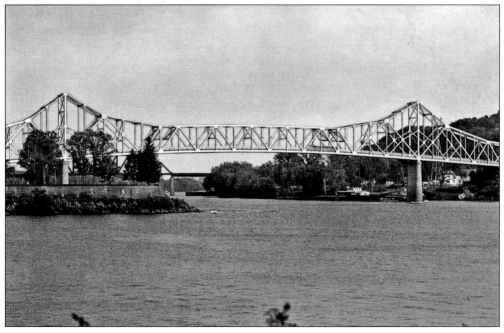

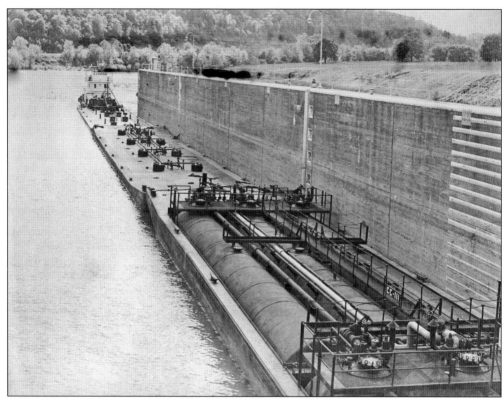

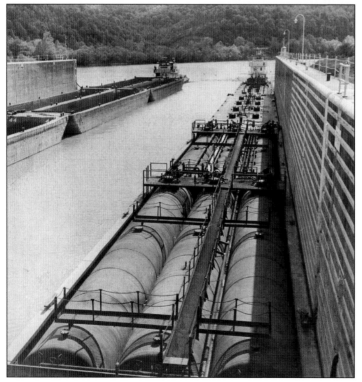

Towboats sit patiently for the Gallipolis Lock and Dam. Located near Gallipolis Ferry, West Virginia, a few miles south of Point Pleasant, the Gallipolis Lock and Dam is one of the many locks on the Ohio River. Currently known as the Robert C. Byrd Lock and Dam, this complex is an important facet of the river industry, maintaining steady water levels for the safety and convenience of towboats and other watercraft. Towboats are a common sight on the rivers around Mason County, particularly north toward the power plants of the River Bend area. (Both courtesy of Roger Clark.)

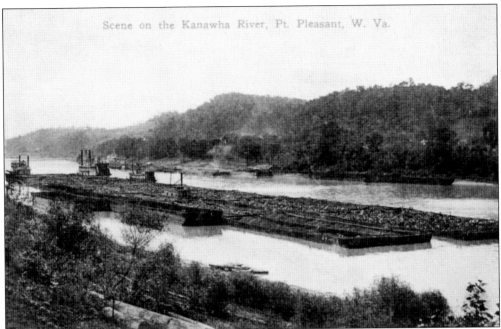

Scene on the Kanawha River, Pt. Pleasant, W. Va.

These postcards, both titled "Scene on the Kanawha River," depict an image of this river as a placid and idyllic place. The Kanawha River, in many ways, was the quieter of the two rivers of Mason County, though not by much. Though it did not receive the volume of traffic commonly seen on the Ohio River, it was nonetheless an important waterway in West Virginia. Besides the coal barges, towboats, and other watercraft flowing up and down its banks, the Kanawha River served as a conduit between Charleston, the capital of West Virginia, and some smaller towns of Mason County, such as Leon, Ambrosia, Arbuckle, and Southside. (Both courtesy of Mike Brown.)

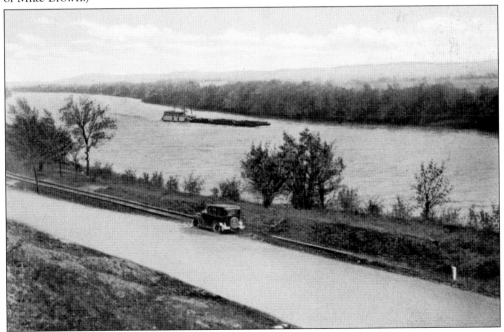

LEAVES BUFFALO AT 6:30 O'CLOCK, A. M., EVERY DAY EXCEPT SUNDAYS. RETURNING, LEAVES GALLIPOLIS A

F. A. BARROWS, Captain.                                                    AUSTIN BARRO

*M B. Sterrett*                    *June 18*

To Steamer **CLARIBELL,**

| MARKS. | To Freight on | Freight. | Charges. | A |
|--------|---------------|----------|----------|---|
|        | *1 Mower Shal* | *25* |          |   |

Received Payment.      *By M Farmer Jr*      Cl

VAN MATRE BROS. PRINT. PT PLEASANT W VA

The *Claribell* was a stern-wheeler, a type of steamboat commonly seen across the river ways. Its hull was built in Leon, a town along the Kanawha River of Mason County, in 1876. The boat was commissioned by Franklin Austin Barrows, who also served as the vessel's captain. Long before the railroads had any strong foothold in Mason County, stern-wheelers like the *Claribell* served as the major transportation craft along the waterways. The *Claribell* ran along the Kanawha, from Gallipolis, Ohio, past Point Pleasant, and on to Buffalo. This route was part of its daily voyage, servicing many of the small towns along the way, especially for mail and supplies from larger cities. In 1878, the boat sank at the mouth of Thirteen Mile Creek in Mason County, and it remained submerged in the water for a few years. (Courtesy of Point Pleasant River Museum.)

**Regular Buffalo, Point Pleasant and Gallipolis Daily Packet.**

Leaves BUFFALO at 6:30 o'clock, a. m., Every Day except Sundays. Returning leaves GALLIPOLIS at 1:30, p. m.

*Oct 22nd* 185_

*Mr Benj. Sterrett*

F. A. BARROWS, Captain.
AUSTIN BARROWS, Clerk.

**To Steamer Claribell,** Dr.

In no case whatever will the Boat be responsible for Freight after she leaves the Landing

| Marks. | To Freight on | Freight. | Charges. | Amount. |
|---|---|---|---|---|
| | 1000 Brick | 50 | 3 00 | 3 50 |
| Received Payment. | Barrow | | | Clerk. |

The *Claribell* lasted through much of the late 19th century, despite its unfortunate sinking in 1878. The boat was raised and continued operation for many years after this accident. The *Claribell* remained in the Barrows family throughout its lifetime and continued operation in one form or another well into the 20th century. The name Barrows can be seen on all of the tickets, either as the boat's captain or clerk. Another Barrows, Ed, also worked on the *Claribell* as engineer. The tickets shown here were used as ledgers and bills of lading for the boat as it made its daily runs. (Both courtesy of Point Pleasant River Museum.)

**Regular Buffalo, Point Pleasant and Gallipolis Daily Packet.**

Leaves BUFFALO at 6:30 o'clock, a. m. Every day except sunday. Returning, leaves GALLIPOLIS at 1:30 p. m.

*Buffalo, July 11 . 1888*

*M. E. Bryan & Bro*

AUSTIN BARROWS
CAPTAIN AND CLERK.

**To Steamer CLARIBELL,** Dr.

| Marks. | To Freight on. | Freight. | Chgs. | Amount. |
|---|---|---|---|---|
| | Pkg Sections | 15 | | |
| | J. P. Barrows | | | |
| Received Payment. | | | | Clerk. |

19

**Regular Frazier's Bottom, Buffalo, Point Pleasant and Gallipolis Daily Packet.**

Leaves FRAZIER'S BOTTOM 6:30 A. M.   •   •   Sundays Excepted.   •   •   Returning, Leaves GALLIPOLIS 1:30 P. M.

*Buffalo Dec 6 1900.*

*Sam a Sterrett*

W. A. BARROWS, MASTER.
GEORGE BARROWS, CLERK.

**TO STEAMER NEVA, DR.**

In no case whatever will the boat be responsible for Freight after she leaves the landing.

| MARKS. | TO FREIGHT ON. | FREIGHT. | CHARGES. | AMOUNT. |
|---|---|---|---|---|
| | 1 Bu Clothing | 25 | | |
| | Received Payment, *Cd Spiner* | | Clerk | |

The riverboat *Neva* was formed from the remains of the *Claribell* after it was dismantled and repurposed. This new boat was constructed in 1898 at the request of Capt. Franklin Barrows. Most of the machinery from the *Claribell* went to the *Neva*. Constructed as a larger vessel than the *Claribell*, the new boat was named after Captain Barrows's daughter. The *Neva*'s hull was 117 feet long and 21 feet wide. Much like its predecessor, this boat ran along the Kanawha River from Gallipolis to Buffalo and provided many of the same services as its earlier incarnation. The *Neva* remained in operation for a number of years until it burned in 1904. (Both courtesy of Point Pleasant River Museum.)

**Regular Winfield, Buffalo, Point Pleasant and Gallipolis Daily Packet.**

Leaves WINFIELD 5: A. M.   Sundays Excepted.   Returning, Leaves GALLIPOLIS 1:30 P. M.

*S A Sterrett Ldg Sep 16 1903*

W. A. BARROWS, Master.
MARVIN WEARS, Clerk.

**To Steamer NEVA, Dr.,**

In no case whatever will the boat be responsible for Freight after she leaves the landing.

| MARKS | TO FREIGHT ON | FREIGHT | CHARGES | AMOUNT |
|---|---|---|---|---|
| | 12 Bu Wheat | 70 | | |
| M. V. Brown | | | | |

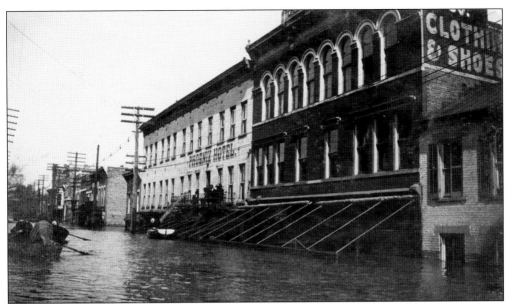

The Phoenix Hotel (the white building at center of both images) was an early establishment on Point Pleasant's Main Street. During its duration as a hotel, the Phoenix, much like the rest of Point Pleasant, incurred damage from the numerous floods in the tumultuous years of the turn of the 20th century. The garish accommodations of the Phoenix Hotel could not withstand the floodwaters as they soaked in from the street. During one year of heavy flooding, the accompanying storms were enough to blow the roof off of the hotel, inflicting extra damage to an already soaked hotel. The Phoenix Hotel was closed by the time of the major floods in 1913 and 1937. (Both courtesy of Bob Keathley.)

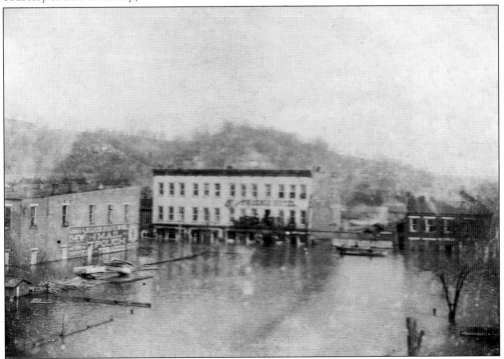

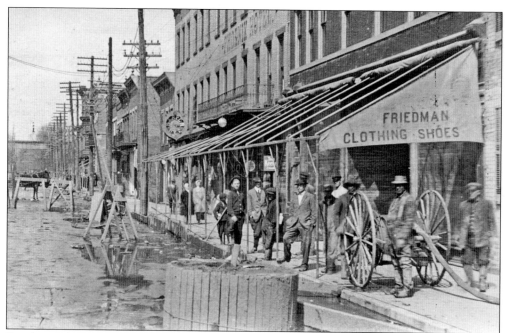

Residents of Point Pleasant organize and clean up the streets in the aftermath of the 1913 flood (above). There were actually two separate floods in this year, both occurring within three months of each other. The first flood reached its peak on January 13, 1913, with the river reaching a height of 50.3 feet. The second flood struck a few months later, cresting on March 30, 1913. The Ohio River elevated to 62.8 feet, the highest recorded level in the river's history for the Mason County area. Residents of Point Pleasant often commuted between buildings on rowboats (below), an odd sight for a street normally filled with pedestrians, horses, and carriages. (Above courtesy of Bob Keathley; below courtesy of Mike Brown.)

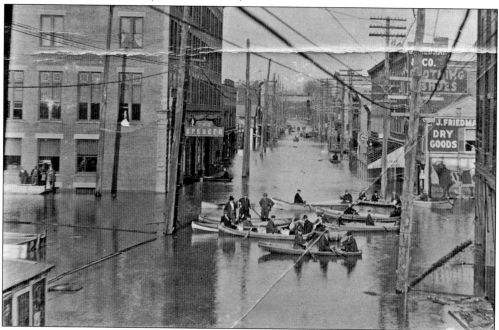

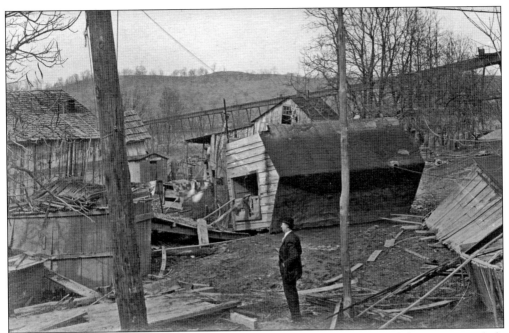

Kingtown is a district of Point Pleasant that was historically susceptible to flood damage, particularly because of its close proximity to the banks of both the Ohio River and Kanawha River. The man in this photograph assesses the damage to some buildings in the Kingtown area after the 1913 flood. (Courtesy of Bob Keathley.)

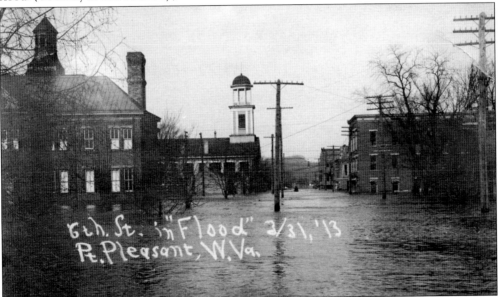

A view down Sixth Street in Point Pleasant during the 1913 flood reveals some of the important buildings that were well in the flood's path. The white building with the bell tower in the left background is the Mason County Courthouse, which held many of the records and other sensitive information of the entire county. Clerks of the court made special care to move the records to higher floors before the floodwaters rushed in. The floods eventually wore down the courthouse building, and the cost of repairs to the building was massive. (Courtesy of Bob Keathley.)

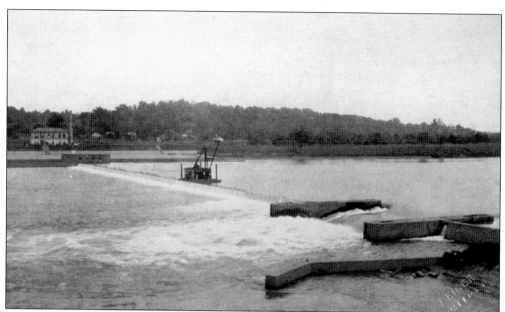

The Racine Locks and Dam (above) were constructed in the 1960s as a means of controlling the flow of the Ohio River. Situated around the town of Letart, the Racine Locks are named after the city across the river from the River Bend area, Racine, Ohio. The picture of the locks' construction below was taken on July 30, 1965. Part of the construction effort involved excavation by dredging the river's waters, as well as the creation of large coffers for storage. (Both courtesy of Bob Keathley.)

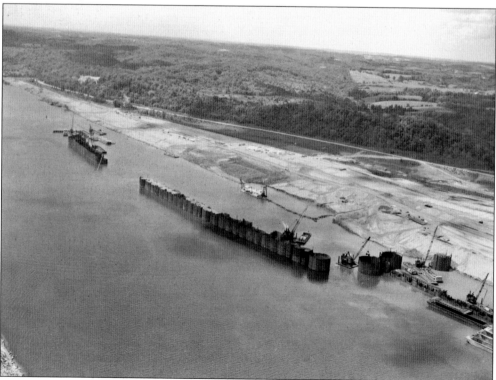

Another image portrays the construction of the Racine Locks and Dam. This picture, dated May 28, 1965, was taken on the West Virginia side of the river. The construction efforts on the Ohio side are reinforcing the river's bank, completing the bank protection on the Ohio side. (Courtesy of Bob Keathley.)

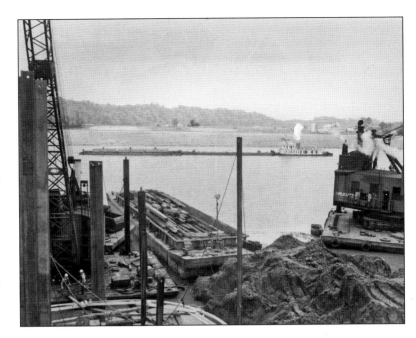

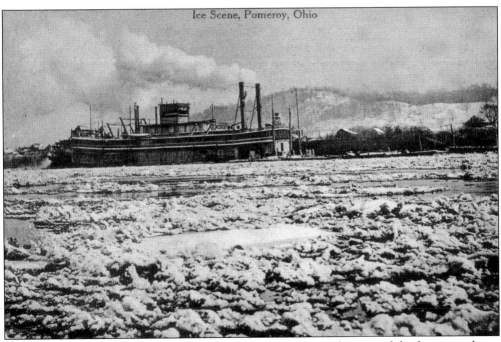

Even though the Ohio River is a powerful force of nature, it can be stopped dead in its tracks, as evidenced in this photograph. A frozen river can be dangerous, trapping boats in its wake. This boat experienced just such a misfortune when the river froze in the winter of 1914. (Courtesy of Bob Keathley.)

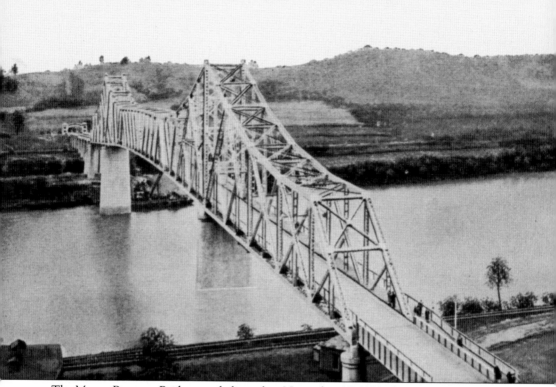

The Mason-Pomeroy Bridge was dedicated on November 12, 1928, the same year as the dedication of the Silver Bridge in Point Pleasant. The bridge was built by the Dravo Contracting Company. The construction of this bridge was a necessary part of the development of the River Bend area of Mason County, connecting the towns of Mason, Hartford, and New Haven to cities such as Pomeroy, Ohio. Before the bridge, ferries were the primary method of crossing the river. As automobile traffic increased, more convenient means for river crossing were needed. The Mason-Pomeroy Bridge, also known as the "Pomeroy Bend Bridge," satisfied the growing needs of the communities. To illustrate this point, the first person to cross the bridge was W. A. Compton, who drove his car across the bridge's span. This bridge was in service for 80 years; it was replaced by a new bridge in 2009. (Courtesy of Bob Keathley.)

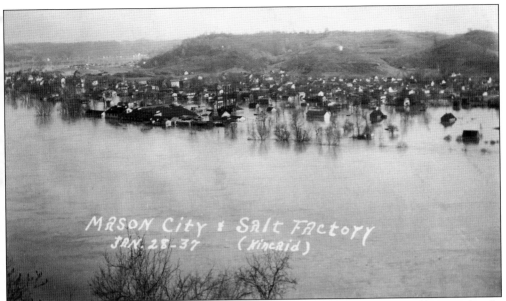

On January 27, 1937, the Ohio River reached a record level of flood stage, climbing to a height of 62.8 feet. This flood stage tied the previous record from the flood of 1913. All the river towns along the Ohio River, especially the ones found in Mason County, were affected by this flood, the most devastating one to date. This picture of Mason, taken a day after the flood reached its peak, demonstrates the extent of the flood's reach, as most of the city rests underwater. (Courtesy of Bob Keathley.)

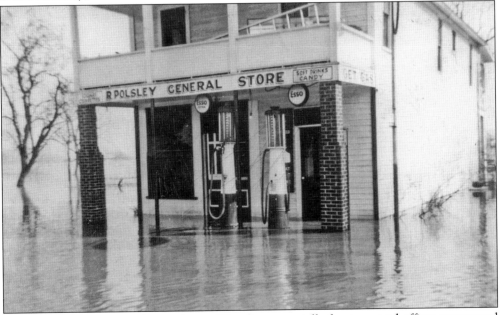

Business was nonexistent during times of flooding, especially for stores and offices sequestered in the small towns and rural areas of Mason County. While much of the damage caused by the floods was physical, the flood's ancillary effects also caused economic damage, as business owners took time off of work to rebuild and restock their items, if they were lucky enough to recover. (Courtesy of Bob Keathley.)

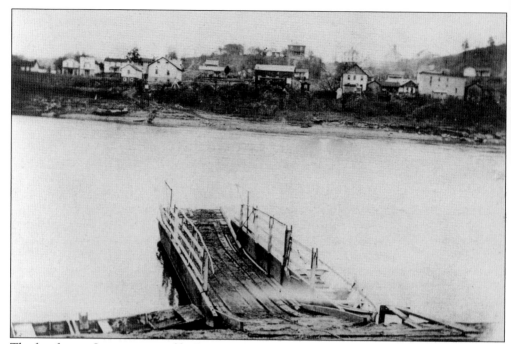

The first ferry in Leon was owned by Benjamin Byram in 1871. The ferry was poled across the river, first by Archibald Whitt and then by John Ferguson, Anna Smith, and Perry Smith. The cost of crossing the river, according to county court, was 5¢ for one person and up to 25¢ for a vehicle. By 1920, a new ferry (below) began operations around Leon. This ferry was owned by Charles F. Thomas and Charles Stone, the latter acting as ferryman. This ferry was no longer poled across the river but rather pushed by engine. On the south side of the river, near the ferry's landing, was a bell on a pole, which was rung to announce the arrival of a new passenger. (Both courtesy of Juanita Burdette.)

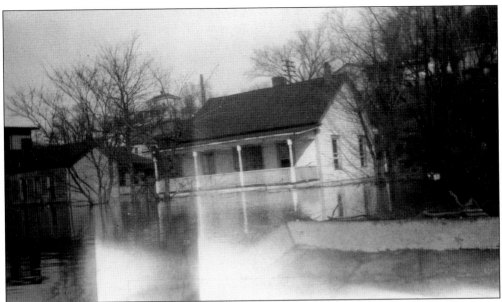

The 1937 flood, like many of the floods throughout the Ohio River and Kanawha River valleys, struck in the middle of winter. This scene, depicting a home flooded in Leon during the 1937 flood, is a typical one when the floods were at their worst. The peak of the 1937 flood occurred on January 27, but the floodwaters remained for many days after the peak. (Courtesy of Natalie Morgan.)

The old iron bridge in Leon was built in 1891 at a cost of $2,700. The bridge replaced an old wooden bridge that crossed Thirteen Mile Creek near the town of Leon. When this rebuilding occurred, a proclamation was made that the bridge "will not only be substantial, but secure." The Leon Bridge remained in operation until 1957. (Courtesy of Juanita Burdette.)

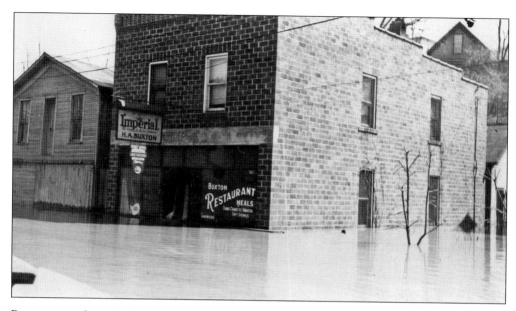

River towns along the Kanawha were no strangers to the river's rampant flooding. Though it flowed into the Ohio River, the flood stages of the Kanawha River were connected in many ways to the Ohio River. The major floods in 1913, 1937, and 1948 affected the towns along the Kanawha River as much as they did for those along the Ohio River, if not more so. In Leon, Buxton's Restaurant, a solid brick building in the middle of town, feels the effects of the flood (above). The 1948 flood, though not as devastating, managed to wreak havoc to Leon (below), especially since the town had no floodwall to protect it. (Above courtesy of Natalie Morgan; below courtesy of Juanita Burdette.)

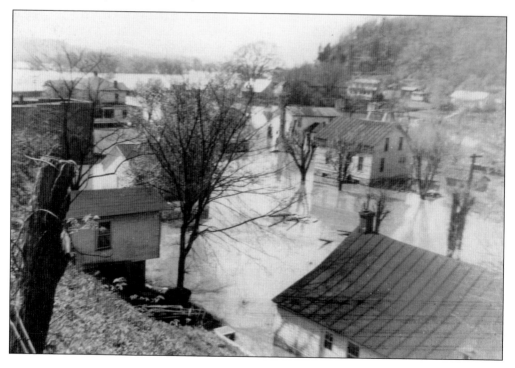

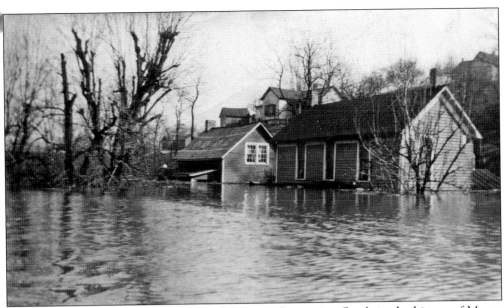

The floods in 1913 and 1937 were two of the most devastating floods in the history of Mason County, especially for those towns situated on the Ohio River. Upstream, along the Kanawha River, Leon experienced some of its worst flooding as well. The Hayman Hotel (below) was flooded throughout much of its first story, and nearly into its second story, during the 1913 flood. Leon proper, though surrounded by hills, had many of its residences flooded as well. In the picture above, homes in Leon are flooded during the 1937 flood. To the left is the home of Dr. Benjamin Franklin Sommer, a respected physician in the area. To the right is the home of Charles Stone, who operated the ferry across the Kanawha River at Leon. (Both courtesy of Juanita Burdette.)

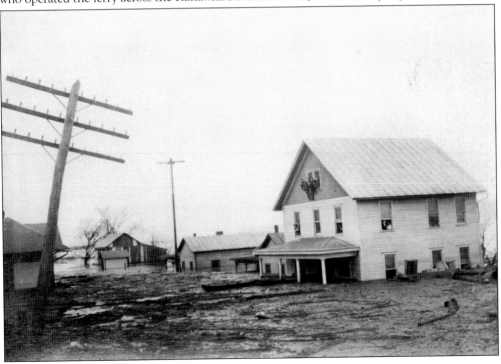

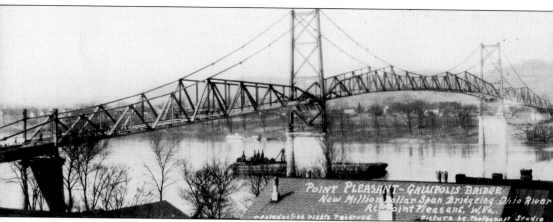

The Gallia Ohio River Bridge Company began construction of the Silver Bridge on May 1, 1927. After a year of construction, the bridge was completed. Its original purpose was as a private toll bridge, conveniently placed in the heart of a burgeoning transportation artery. The Silver Bridge was the only bridge across the Ohio River between the Mason-Pomeroy area in the northern part of Mason County and Huntington, West Virginia, located about 46 miles downstream. The first people to cross the bridge were Robert Heslop and James D. Robinson. The total length of the Silver Bridge was 2,235 feet; the bridge was 22 feet wide, or enough for two lanes of automobile traffic and one pedestrian walkway that was 6 feet wide. (Courtesy of Bob Keathley.)

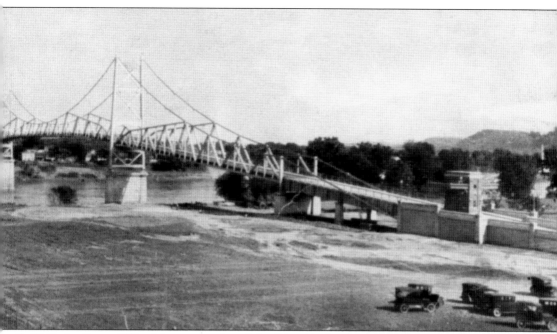

By 1940, the State of West Virginia purchased the Silver Bridge for a price of just over $1 million. Though it was still a toll bridge at the time of purchase, within a decade, the Silver Bridge was reopened as a free, public bridge across the Ohio River. The bridge had a unique design, and only one other bridge was constructed with a similar structure. Essentially a suspension bridge, the entire structure was held together with cables strewn from towers across the river. Eyebar joints held the cables in place. By the standards of automobile traffic and bridge construction in the 1920s, the bridge was a beautiful creation, the gleaming silver of its aluminum paint reflecting off of the Ohio River. (Courtesy of Jack McCoy.)

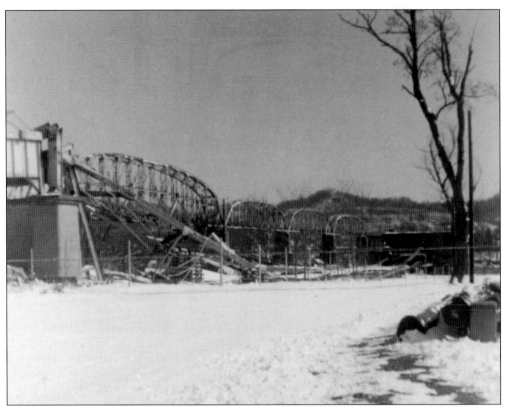

On December 15, 1967, the Silver Bridge collapsed into the Ohio River, plummeting 37 vehicles, the bridge's towers and cables, and the entire span of road into the cold waters below. Many of the people flung into the river were trapped in their vehicles and under large slabs of debris and wreckage from the bridge. Rescue crews arrived immediately, but before long, the bulk of the damage was already inflicted. The bridge's collapse caused 47 people to die in the frigid waters of the Ohio River, many of them local commuters traveling to their homes on either side of the Ohio River. (Above courtesy of the Arnolda Carpenter; below courtesy of Mothman Museum.)

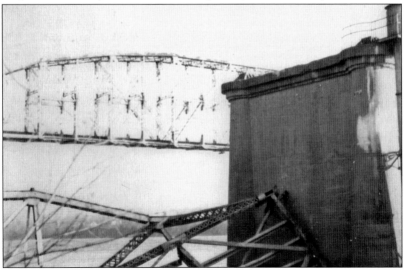

Volunteers worked around the clock to recover bodies from the river, assist in rescue efforts, and unravel the massive entanglement of cables, concrete, and chaos that spilled into the river after the bridge collapse. Among the first groups on the scene was the Coast Guard, who quickly organized the recovery efforts. The American Red Cross had 150 volunteers working around the clock in the area as well. Efforts to dredge the waters of the Ohio River were hampered by the murkiness of the winter's waters, as well as the deep, persistent cold of the December air. (Both courtesy of the Mothman Museum.)

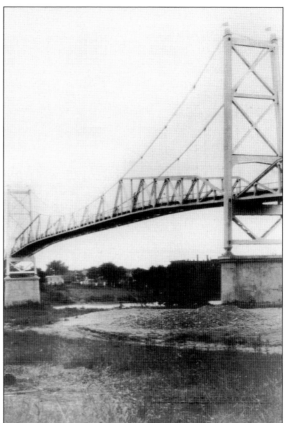

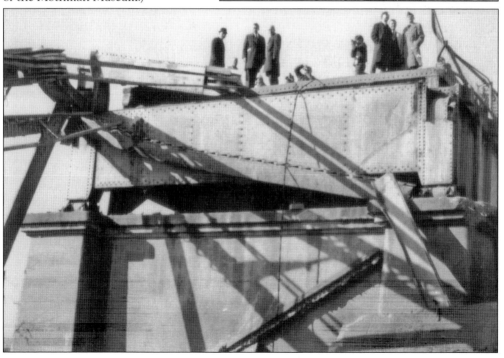

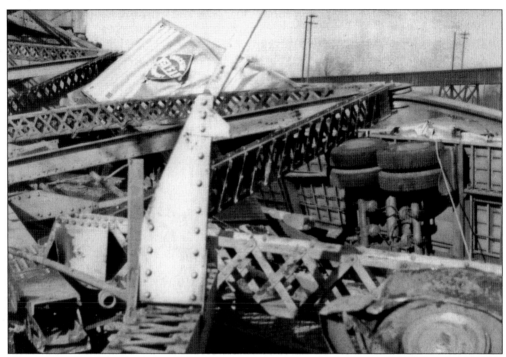

The investigation into the cause of the Silver Bridge's collapse began immediately after the disaster. After months of research, a verdict was finally decided upon by the National Transportation Safety Board. Surprisingly, part of what made the Silver Bridge unique was also the agent of its destruction, as one of the eyebar joints suspending the bridge's cables cracked and buckled under the pressure. Within 60 seconds after the initial joint gave, the entire bridge collapsed, folding into itself and crumbling haphazardly into the waters below. The bridge simply was not designed to withstand the bulky weight of automobiles in the 1960s, designed as it was when cars were smaller and lighter. (Both courtesy of the Mothman Museum.)

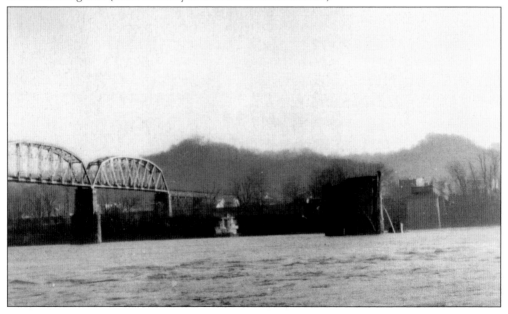

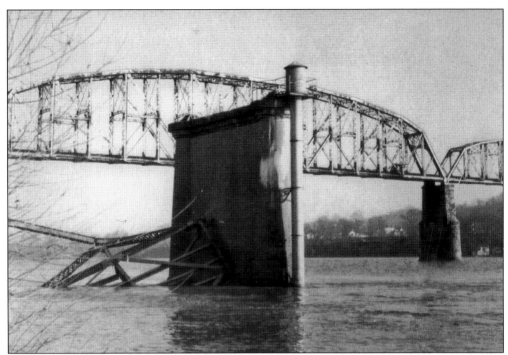

The growth of Mason County can in many ways be tied to the construction of the Silver Bridge, which acted as a convenient means of travel from the busier highways of the Northeast and Midwest into the lands of the Appalachian Mountains. For these reasons, a new bridge was quickly built to replace the Silver Bridge. This new bridge, named the Silver Memorial Bridge, was constructed in a remarkably quick turnaround. Within two years, the Silver Memorial Bridge, a four-lane bridge spanning the Ohio River between Gallipolis, Ohio, and Henderson, West Virginia, was erected, and a new "Gateway to the South" was opened. (Both courtesy of the Mothman Museum.)

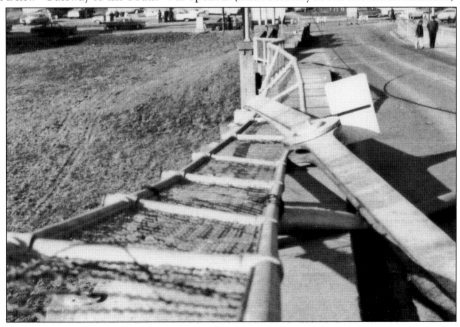

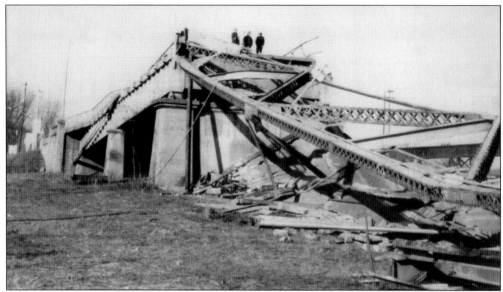

The only part of the bridge that did not collapse into the Ohio River was the approach ramp on the Ohio border (above). The rest of the 2,235-foot span was stuck in the water, awaiting rescue by the engineers, volunteers, and officials who arrived to aid in the recovery efforts (below). Until the construction of the Silver Memorial Bridge, the nearby railroad bridge, which was constructed 10 years prior to the Silver Bridge, served as a commuter rail, taking passengers across the river between Point Pleasant and Gallipolis. A ferry was also in service during this intermittent period, the first time a ferry operated across the river in this vicinity for decades. Through it all, though, the people of Mason County struggled and survived the tragedy, pushing forward into the murky depths of the future. (Both courtesy of the Mothman Museum.)

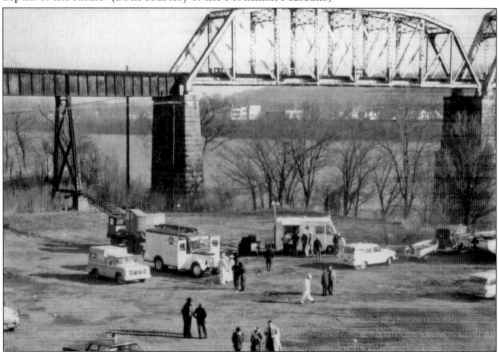

# Two

# ALONG THE KANAWHA

The Kanawha River represents the natural cross-section of Mason County, a surging line across the belly of the county. Flowing from the mountains to the south, the Kanawha River is not as powerful as the river it pours into, but it is nonetheless important to Mason County's history and culture. The word "Kanawha" is a Native American word meaning "place of white stone," and it is the longest inland waterway flowing in the state of West Virginia.

Many of the communities along the Kanawha River in Mason County are quiet towns and small communities that have remained, for the most part, at very steady population levels throughout their history. These villages and hamlets are not the boom-and-bust towns of the northern River Bend area, whose population flux is as dramatic as the Ohio River herself. Rather, the communities along the Kanawha River consist of the same concentration of people that they have had from the start.

Discounting Point Pleasant and Henderson, covered in greater detail in chapter 4, the largest community along the Kanawha River in Mason County is Leon, whose incorporation into the county came much later than other towns in the area. A similar story can be found for the other communities along the Kanawha, whose formation and growth are subtle additions to an already established county.

The pace of the Kanawha River towns is slower and more sedated than their brethren along the Ohio. Though the river is the hub of the community, it does not support the expansion it afforded others in the area. Instead, the Kanawha River serves as a minor variation on the Ohio River's theme. Riverboats float down its course, but not to the extent of the Ohio's; floods swell and surge from the riverbanks, but the damage is not as extensive; towns erupt from the water, but not as large. Nevertheless, though the pace is different, the area is still important and thriving, a unique flavor different than the other parts of Mason County.

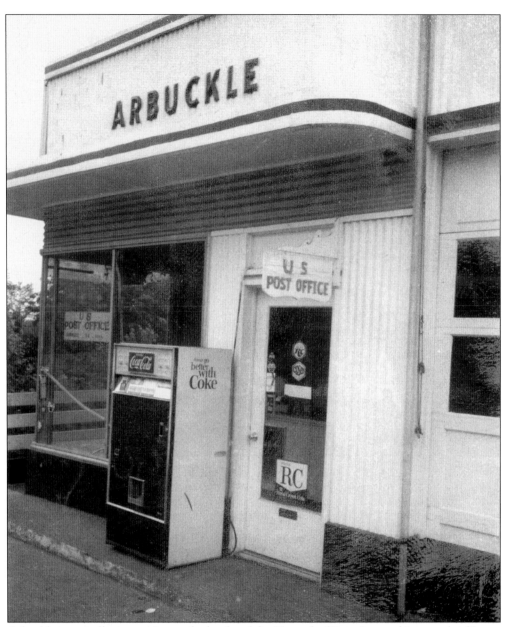

Arbuckle is a small community on the banks of the Kanawha River. Located just south of Leon, it is one of the small river towns that sprang up along the Kanawha River in the 19th century. The town is named after Capt. William Arbuckle, an early pioneer of Mason County. Matthew Arbuckle fought beside Andrew Lewis in the Battle of Point Pleasant in 1774. William Arbuckle served alongside his brothers, Matthew and John Arbuckle, at Fort Randolph, located at the meeting of the Kanawha and Ohio Rivers in Point Pleasant. Capt. William Arbuckle also served alongside George Rogers Clark in the later years of the 18th century. Arbuckle's family was very prominent in the formative years of Mason County, and communities such as Arbuckle portray his influence on the county as a whole. In his later years, William Arbuckle maintained residence on the banks of the Kanawha River. The Arbuckle Post Office is shown here. (Courtesy of Point Pleasant Post Office.)

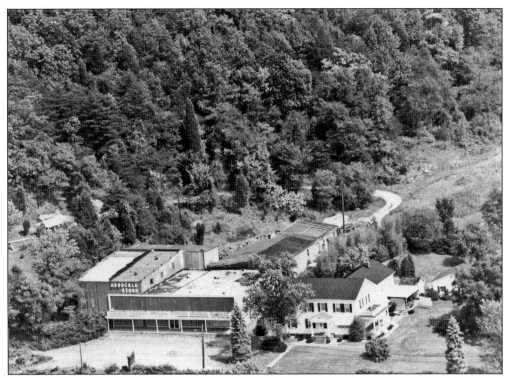

Arbuckle was never a large community, but it did maintain some large business establishments in its history. One such company was the Arbuckle Furniture Store. This store began as a business venture by Perry Avril Sayre in the early 1940s. The first furniture of this company was sold out of the back of a school bus. Within 10 years, the business grew, and the furniture store had a proper building (below). Sayre's business was one of the largest in Arbuckle, and he later expanded his business to include tractor sales. The aerial shot of the Arbuckle Furniture store above was taken in 1986, a few years before Perry Sayre died. (Both courtesy of Keith Sayre.)

Ernest Sayre stands amid the streets of Arbuckle on February 4, 1939. In the early part of Arbuckle's history, the towns of Leon and Arbuckle were greatly connected, oftentimes considered the same town. By the end of the 19th century, however, Leon and Arbuckle became distinct enough communities. (Courtesy of Keith Sayre.)

Grimms Landing's original post office was built in 1878 by George Grimm near the banks of the Kanawha River. Located near the edge of the Mason County line, Grimms Landing is situated on Arbuckle Creek, which flows into the Kanawha. In the early days of the post office, mail would be delivered via river to George Grimm at his office. (Courtesy of Point Pleasant Post Office.)

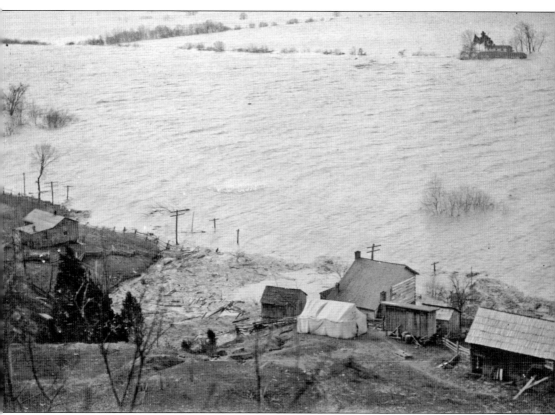

Ambrosia is another community on the banks of the Kanawha River, small even by Mason County terms. In the 1913 flood, Ambrosia, like many of the towns and villages along the river, suffered massive damage from the deluge of water sweeping through it. Unlike cities such as Point Pleasant and Mason, the people of Ambrosia did not have the means to recover well from the damage of the flood. Like every other river town in the county, Ambrosia's livelihood depended on the river and nature's curious whims. The 1913 flood was one of the most devastating of the 20th century; the Ohio River reached a record peak during this flood, while the Kanawha River followed close behind. Two major floods occurred in 1913, in January and March, an especially wet winter and spring for Mason County. Though overcome by the flood, Ambrosia persisted, its welfare constantly dictated by the state of the river. (Courtesy of Bob Keathley.)

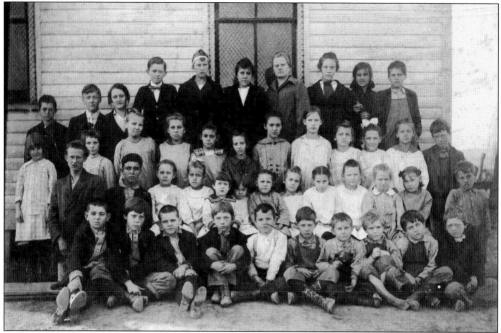

The Beech Hill class of 1939 poses for their class picture below. Bernice Anderson was their teacher. The students are, from left to right, the following: (first row) Anna Lee Wears Smith, two unidentified, Clara Catherine Yauger, and unidentified; (second row) Lawrence Newell, unidentified, Kitty Lou McCarty, Howard Rhodes, and Robert McCarty; (third row) Bertie Catherine Wears Woodard, Hopie Newell Higginbotham, and three unidentified. Earlier in the school's history, a class of schoolchildren poses for their class picture around 1916 (above). Beech Hill was a long-standing school building for children living along the Kanawha River, joining many of Mason County's other small schools found in its more rural areas. (Both courtesy of Catherine Yauger.)

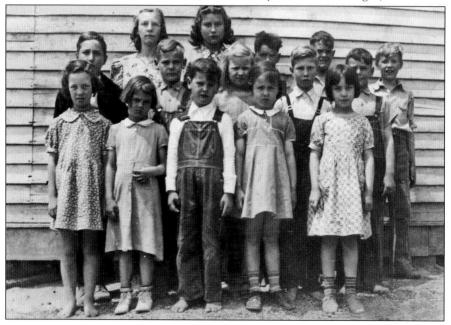

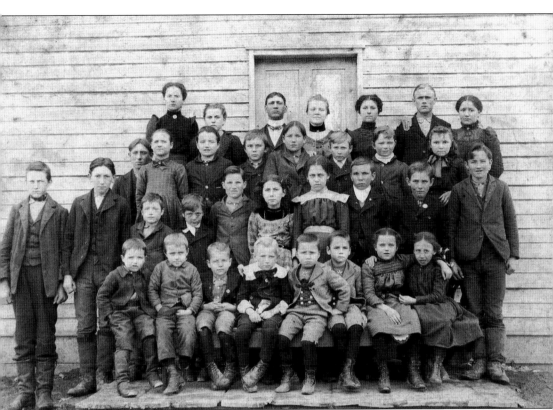

Another class of the Beech Hill School, around 1913, is pictured here. Beech Hill School was one of the "free schools" to emerge after the Civil War. School lessons took place in the building known as town hall, a structure situated on land that was once part of George Washington's settlement. The building was constructed near the end of the Civil War for purposes of public meetings in the Arbuckle District of Mason County. In 1902, the building moved to the juncture of Nine Mile Road and River Road. Beech Hill School derived its name from Beech Hill Church, located across the Kanawha River. Throughout its history, Beech Hill has remained a staple in a small community. Among its alumni are Byrd Hill and his brother David Hill, who both went on to become members of the West Virginia Legislature. (Courtesy of Catherine Yauger.)

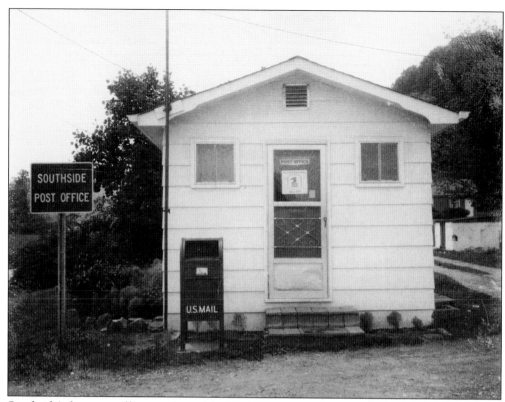

Southside's first post office was formed in 1886. The community was known as Southside, as it was nestled on the southern banks of the Kanawha River. For a time, Southside was known as Harmony. The first postmaster of Southside was Nathan Long, who was also one of the early settlers of the Southside community. (Courtesy of Point Pleasant Post Office.)

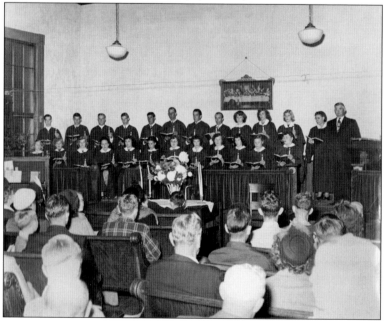

One of the staples of the Southside community was the Harmony Baptist Church. In this picture, a robed adult choir performs during a c. 1950 ceremony, most likely for one of the weekly services. Performing at the piano is Irene Brand, who would later become one of Mason County's local authors. (Courtesy of Rod Brand.)

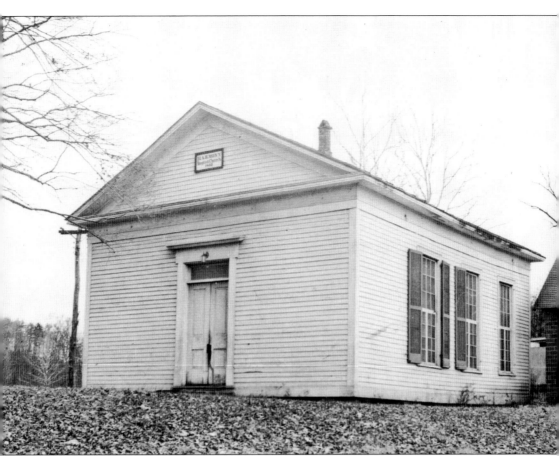

Harmony Baptist Church was founded in Southside, West Virginia, in 1812. It is one of the earliest churches organized west of the Allegheny Mountains. Harmony Baptist Church is situated at the mouth of Little Sixteen Creek. When the church was formed, there were only 16 charter members, but patronage of the church quickly grew. The present church was constructed later in the century; the dedication of the church occurred on the second Sunday of October, 1860. A simple, solemn, and elegant building, the Harmony Baptist Church has remained in its location for over 135 years, with a few adjunct rooms added to the building as the church flourished over time. In its early years, Harmony Baptist Church was known for imposing strict guidelines for conduct among its members, particularly in regards to attendance of church services on a regular basis. Failure to adhere to these guidelines meant expulsion from the church community. (Courtesy of Rod Brand.)

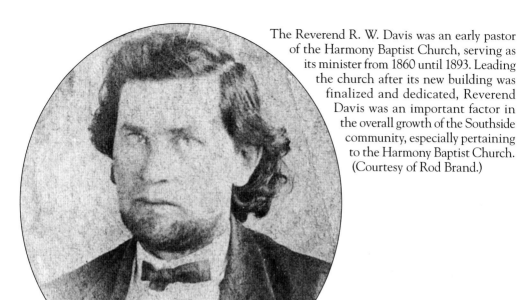

The Reverend R. W. Davis was an early pastor of the Harmony Baptist Church, serving as its minister from 1860 until 1893. Leading the church after its new building was finalized and dedicated, Reverend Davis was an important factor in the overall growth of the Southside community, especially pertaining to the Harmony Baptist Church. (Courtesy of Rod Brand.)

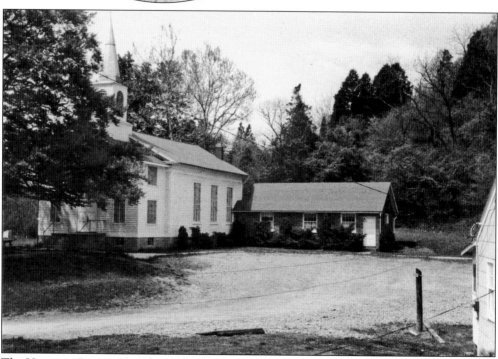

The Harmony Baptist Church building has evolved numerous times over the years. In 1940, the addition of three Sunday school rooms brought extra space for the religious education of the church's youth. The church was raised and a basement added in 1948, along with a new furnace. (Courtesy of Rod Brand.)

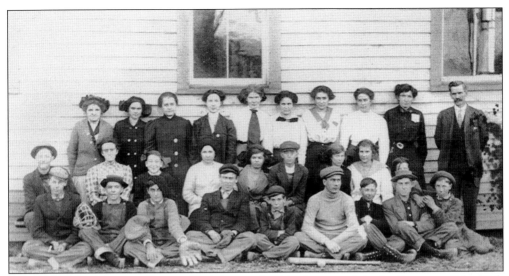

Members of the Harmony Baptist Church pose for this photograph in the first part of the 20th century. Churches were more than places of worship; they were also hubs for social activity and places for families to gather, whether for a picnic, celebration, or festival. (Courtesy of Rod Brand.)

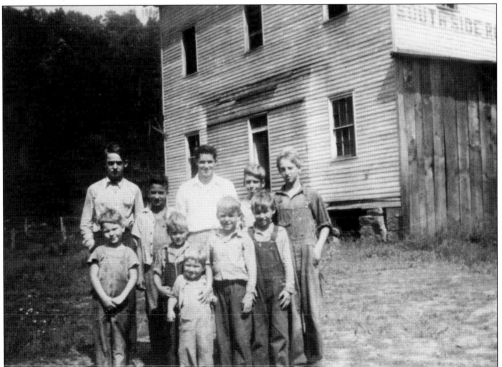

Young boys prepare for Sunday school for Harmony Baptist Church around 1944, a few years after the addition of the Sunday school classrooms. Behind the boys stands the Southside Roller Mills, located near the church. The boys are, from left to right, (first row) Leonard Norvelle, Jim McCallister, Larry McCallister, unidentified, and Bob McCallister; (second row) Donald Saxton, Paul Spicer, Allen McKinney, Judson Norvelle, and Delbert League. (Courtesy of Rod Brand.)

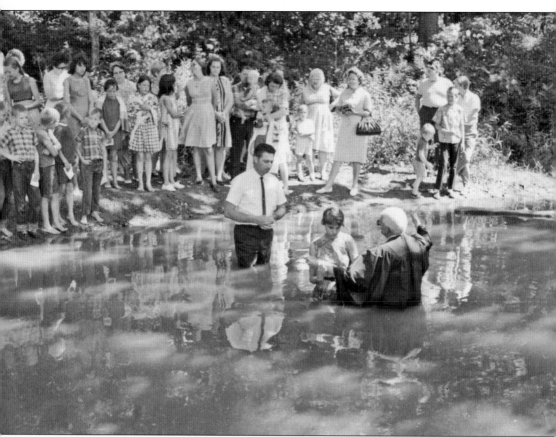

The creek beds, streams, lakes, and rivers of Mason County were utilized for more than just business and transportation purposes. They also served a spiritual function as well. These waterways, regardless of their size, served as the foundation for the communities, the basic network that provided sustenance to the entire county. Indicative of this spiritual function that the waterways served are the immersive baptisms performed by many of the churches throughout the county. The community of Harmony Baptist Church performs a 1950s baptism service in Five Mile Creek near the Concord Baptist Church. Baptisms were an important part of the spiritual growth of an individual, and performing the ritual in the creeks and rivers of the county served as an important metaphor, as the individual is not only cleansed in the waters, but is renewed as a member of his community around him. (Courtesy of Rod Brand.)

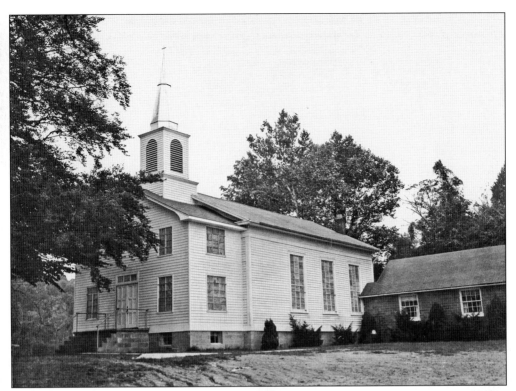

Further additions to the Harmony Baptist Church were made in 1960, sixteen years after the first stage of the church's restoration. This addition brought a new vestibule and bell tower to the church's roof. With these changes, the Harmony Baptist Church arose as a notable landmark along the Kanawha River. (Courtesy of Rod Brand.)

Jabez Beard paints a part of the Harmony Baptist Church around 1945. Though the Southside community was small, there were a few business establishments in the area, particularly around the juncture of Sixteen Mile Creek and the Kanawha River. The Southside Post Office was located in this proximity, as well as the Southside Roller Mills. (Courtesy of Rod Brand.)

Two residents of Southside offer applications for service in the Point Pleasant Post Office. George Hereford (above) applied in 1928, while Virgil E. Hereford (below) applied in 1922. While Southside had an established post office in its community, the allure of a larger town such as Point Pleasant brought multiple job applications from residents all over the county, and though Southside is a few miles away from Point Pleasant, the seat of Mason County, the position of postmaster or postal clerk was a rather attractive position for residents of a small hamlet such as Southside. (Both courtesy of Point Pleasant Post Office.)

The first post office was established in Leon in 1831. From that time until 1880, the post office (and the town) went through a number of different name changes, from Arbuckle to Cologne, until finally settling on Leon. The post office shown below was constructed in 1880. John Ferguson (left) was the postmaster there from 1897 until his death in 1915, a year after this picture was taken. Juaniata F. Amos (center) resumed the postmaster duties after his death; she remained at that post until 1933. Perry Smith (right) was a local merchant and druggist in Leon. (Both courtesy of Juanita Burdette.)

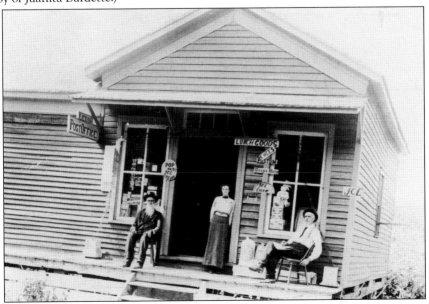

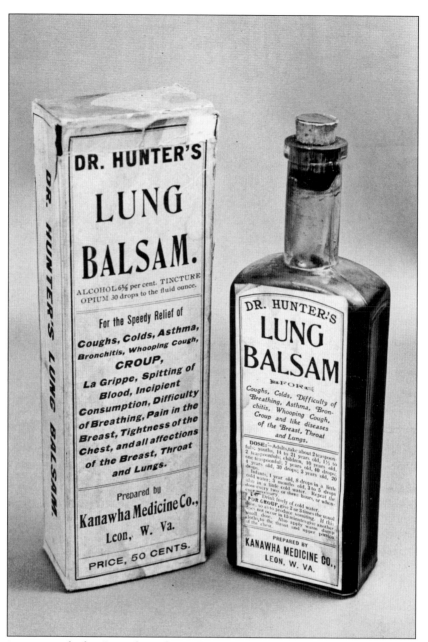

Tonics, tinctures, and other "miracle medicines" were not uncommon in Mason County throughout its history. George Knapp Sr. produced this tonic under the guise of the Kanawha Medicine Company of Leon, West Virginia. The tonic, called Dr. Hunter's Lung Balsam, was 6.5 percent alcohol and contained 30 drops of opium to the fluid ounce. The medicine claimed to cure everything from coughs and colds to croup, asthma, and whooping cough, as well as similar diseases of the "Breast, Throat and Lungs." The recommended dose for those suffering from croup is as follows: "Give 2 or 3 times the usual dose, so as to produce vomiting. If this does not occur in 15 minutes give another small dose. Also apply warm damp cloths to the throat and upper portion of the chest." The Kanawha Medicine Company went out of business from lack of opium. (Courtesy of Juanita Burdette.)

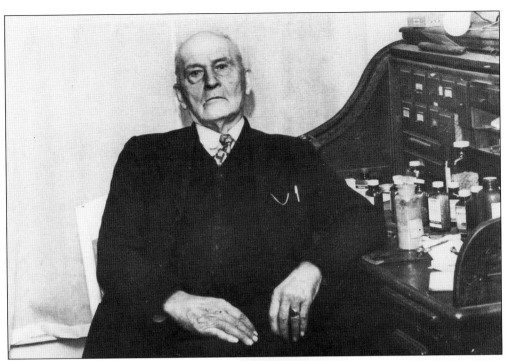

Dr. Benjamin Franklin Sommer was a local doctor based in Leon. Born in 1875, Dr. Sommer became a licensed physician in West Virginia in 1900. After establishing his operations in Mason County, he served as a physician for over 55 years. Until 1920, he would travel by horse on visits to his patients. Dr. Sommer maintained his own drug supply and never wrote a prescription. He concocted and delivered many of his own medicines for his patients. Much of his practice was done alone and without help, and he performed many disparate actions of medicine: amputation, dentistry, and regular checkups. He is estimated to have delivered over 5,500 babies in Mason, Jackson, and Putnam Counties. Dr. Sommer continued to practice medicine until his death in 1965 at the age of 89. (Both courtesy of Carolyn Sommer Costen Hartenbach.)

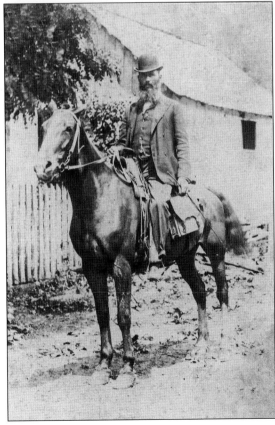

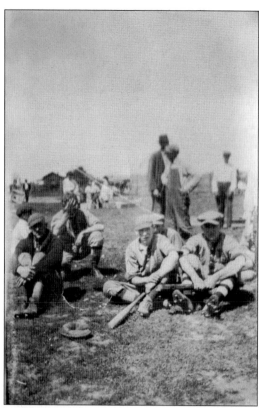

Like other towns around Mason County, such as New Haven and Hartford in the northern part of the county, Leon had a small local baseball team. The picture of this team was taken around 1920. For much of the 20th century, baseball was the most popular sport in Mason County, and though a small team, Leon was no exception to the sports fashion of the time. (Courtesy of Natalie Morgan.)

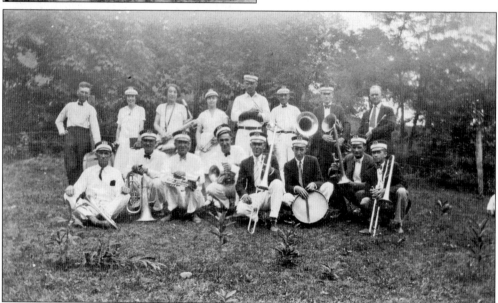

The Leon Band poses for a photograph sometime in the 1920s. Local organizations in Leon were abundant during this time, many of them run by local volunteers or with connections to other community groups and events. Local merchants such as Charles Thomas, who owned the Thomas General Store, were very generous in their donation to groups such as the band, even providing instruments to the young musicians of Leon. (Courtesy of Natalie Morgan.)

# Turkey day. Leon 1915.

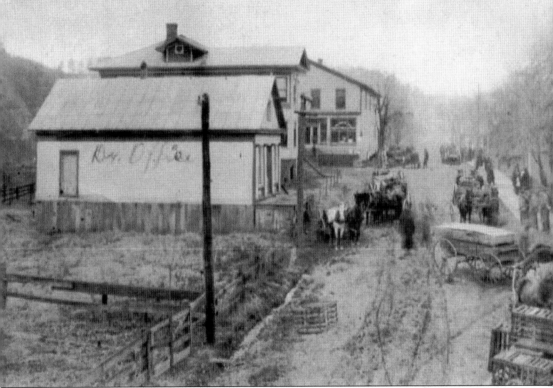

"Turkey Day" in Leon, though occurring around the national Thanksgiving holiday, had an altogether different meaning than in common parlance. For the residents of Leon, Turkey Day was the special day when the town was filled with people and the streets were at their busiest. Every year on the week before Thanksgiving, the surrounding farmers would gather up their chickens, ducks, and turkeys and travel to Leon. Once there, the birds would be collected and packed onto riverboats for transportation to other cities along the waterways. The *Senator Cordel* was often the packet boat chosen to perform this duty, waiting on the banks of the Kanawha River to receive hundreds of clucking, squawking birds. Residents of Leon remember this day fondly as the time when the streets were filled with people and the noise from the season's ubiquitous fowl. (Courtesy of Juanita Burdette.)

Leon was never considered a large town in Mason County, dwarfed as it was by many of the other, larger cities near it. In 1880, the population of Leon was 309 people, and the town's population has not had much fluctuation from that demographic. The community, originally called Cologne, is nestled between the hills of Mason County and the banks of the Kanawha River, as can be seen above. The streets of Leon were small and had only a few businesses, but they were nevertheless busy for a quiet, bustling town (below), even well into the middle of the 20th century. (Both courtesy of Juanita Burdette.)

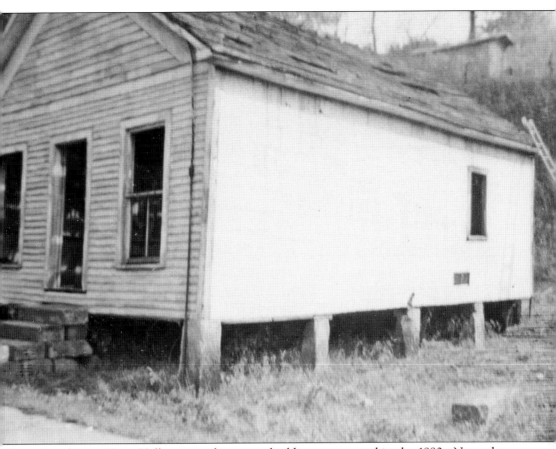

The original Leon Town Hall was a multipurpose building constructed in the 1880s. Not only did the building serve as a community center, but it was also the original classroom, civic center, and meeting hall for the citizens of Leon. The Leon school eventually moved out of this tiny, one-room building and into a four-room building on a hill overlooking Leon. When the new school building burned down in 1943, the town hall was again used as a classroom but this time confined to only fourth-grade students. In 1899, a committee of Leon residents was assigned to construct an addition to the town hall. This extra space was known as a "calaboose," or a local jail. Leon's original town hall remained until the 1960s, when it was replaced with a new building. (Courtesy of Juanita Burdette.)

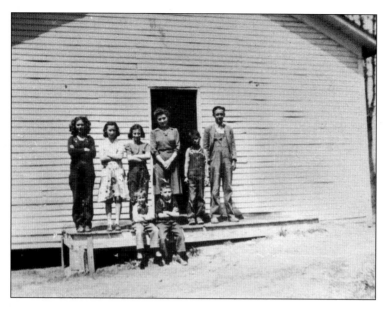

The Bearwallow School was another small, one-room school located in the eastern part of Mason County. One-room schools were common in the county. In 1926, Mason County had dozens of them. Many of the schools had only a handful of students, but before long, the schools were concentrated into larger districts and school systems. (Courtesy of Karen Fridley.)

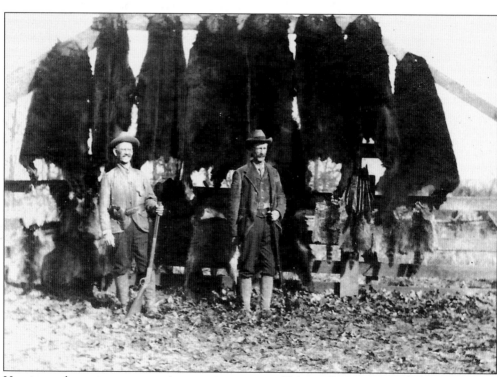

Hunting and trapping were prominent activities in rural Mason County, particularly in the earlier years of the 20th century. For many, hunting was a necessity, not a sport, and the land was rich with wild animals to hunt and trap. These men, members of the Musgrave family, pose in front of some of their recent killings. The Musgraves owned a farm outside of Leon. Bears are rather uncommon sights in the area, and these bears were probably shot and killed in another county. (Courtesy of West Virginia State Farm Museum.)

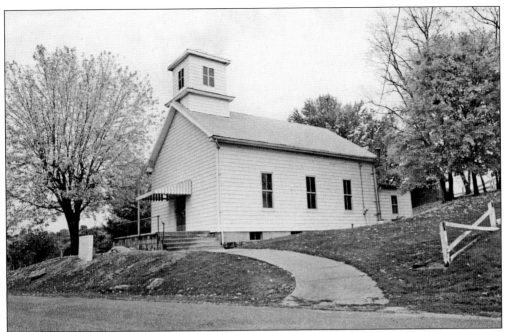

The Leon Methodist Church formed in 1866 on the land of Jeremiah and Sarah Yauger. The first minister of this church was Rev. C. W. Swartz. Leon Methodist Church sits on a high point overlooking the Kanawha River, a serene scene for any religious community. Though there was a Methodist community in Leon for a number of years prior to this church's construction, there was no formal building for worship. (Courtesy of Juanita Burdette.)

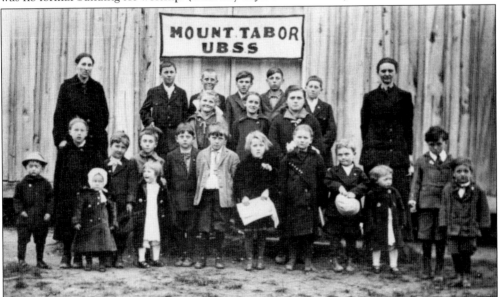

Children pose for a picture in front of the Mount Tabor UBSS around the dawn of the 20th century. The Mount Tabor UBSS is located just outside of Leon, and this gathering of children is most likely for Sunday school. Religious education was an important part of a child's growth and development, and in Mason County, particularly around this time, this was often the first education that a child received. (Courtesy of Arnolda Carpenter.)

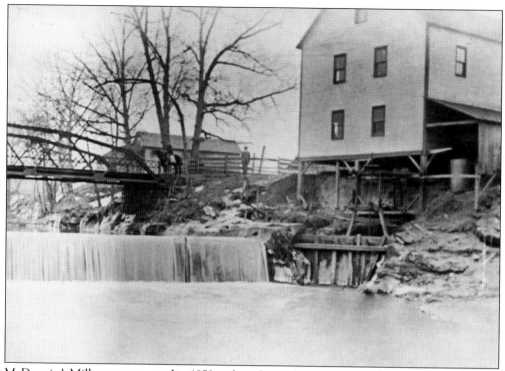

McDermitt's Mill was constructed in 1850 and was located on Thirteen Mile Creek in the Deerlick area. There were many mills around Mason County during this time period, especially near the creeks of the eastern part of the county. The Deerlick Mill was nearly washed away in the 1910 flood, but it managed to rebuild and continue its services for a few years afterward. (Courtesy of Juanita Burdette.)

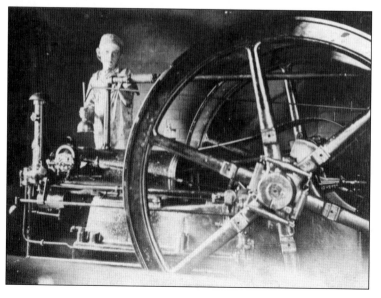

A worker stands in the basement of the Leon Milling Company, preparing to start the mill's machinery. While a number of mills were in operation around Leon, the ready access to rivers, creeks, and streams allowed for other parts of the county to have milling operations, such as Point Pleasant Heights and Deerlick. (Courtesy of Natalie Morgan.)

The Buxton Restaurant (right) was built on Leon's Main Street in the 1920s. The building, constructed by Horace A. Buxton, was a combination restaurant and ice cream parlor from the 1920s until the 1940s, when Buxton changed the building into a grocery store. Horace Buxton also owned and operated the Buxton Mill (below), the largest mill along Thirteen Mile Creek. Beside the mill is a covered bridge, which crosses the Waterloo Dam. Constructed in 1877 by F. W. Sisson, B. S. Smith, and Adam Stewart, the covered bridge is unique in the Kanawha River community of Mason County. The Buxtons continued to own the Buxton Mill until 1921, when they sold the business to William Hayes. (At right courtesy of Juanita Burdette; below courtesy of Natalie Morgan.)

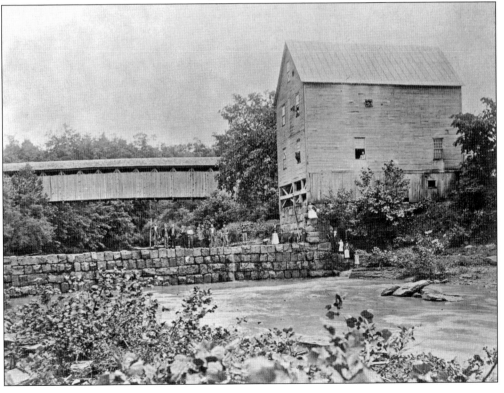

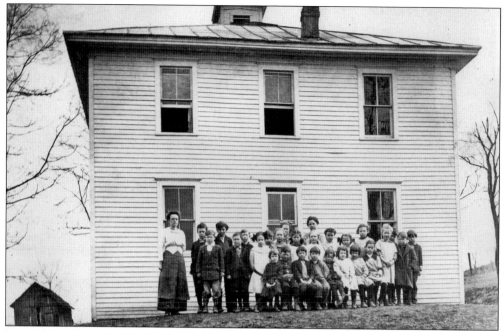

Leon's first school was begun in 1828 by Allen Young, who conducted class in a small, one-room log building. By the 1850s, a subscription school was in place, where $2.50 bought three months' tuition for one pupil. The Leon School shown here was a four-room building constructed around the beginning of the 20th century. The classrooms were in operation until 1945, when the entire building was destroyed by fire. The Leon School was situated above the town of Leon, and the ringing of its classroom bell reverberated throughout the town. When the building was destroyed, the bell was saved, and it now rests in the current Leon Elementary School. (Both courtesy of Natalie Morgan.)

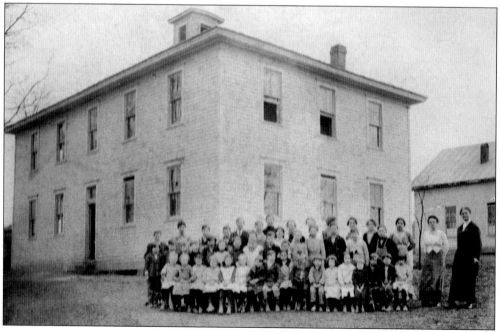

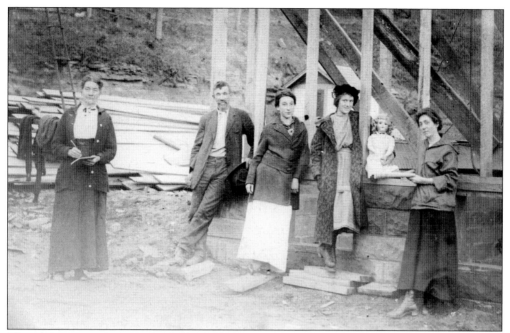

Though Leon was a community no larger than a few hundred people, a number of businesses cropped up along its streets in the early part of the 20th century. Among them was the Thomas General Store, a family-run operation dealing in the necessities and vital goods of a rural community. These two pictures show various stages of the Thomas General Store as it was built. One picture (below) shows the store's foundation being formed. The Thomas family poses for the other (above). From left to right, they are Kate Thomas, Charles Thomas, Lucille Thomas, and two unidentified women. (Both courtesy of Natalie Morgan.)

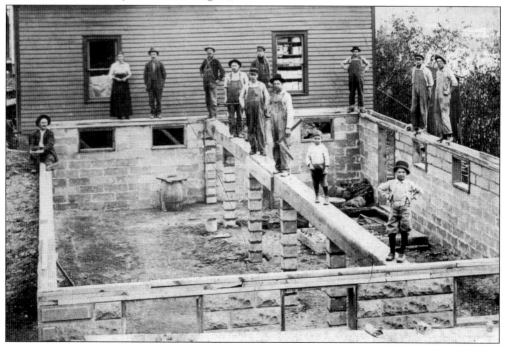

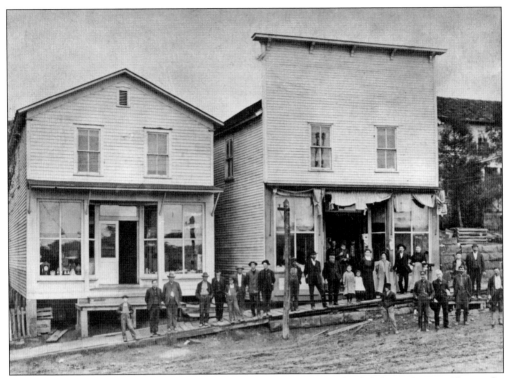

Charles Thomas rented the building hosting his general store (right) from George Knapp Sr. for many years. The monthly rent for the building was $10. After a few years, he built a new structure (below) across the railroad tracks in Leon. The store was a staple of the Leon community throughout the early part of the 20th century, and Charles Thomas involved himself in many of Leon's community programs. The second story of the Thomas General Store was open to the community for gatherings and other events at no cost whatsoever. Plays, charities, community meetings, and other events were held atop his store. The Thomas General Store burned in October 1922, along with other nearby buildings. (Both courtesy of Natalie Morgan.)

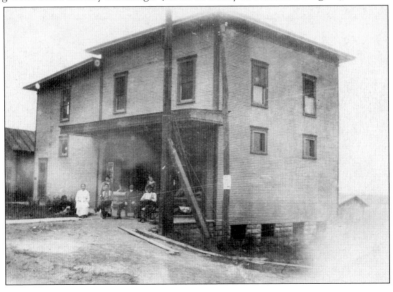

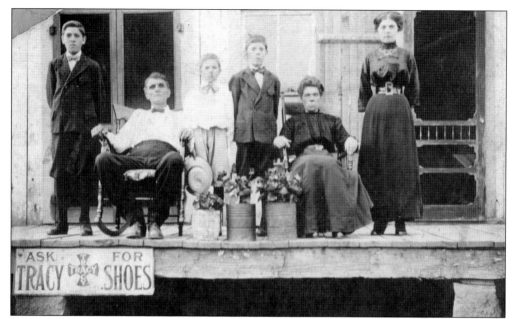

The Stewart General Store was another family-owned outfit on Broadway Street in Leon. Like other stores in the town, this business offered a broad variety of goods for people to purchase, including items not readily available in the area. The Stewart family sits on their porch. They are, from left to right, Ray Stewart, Samuel Stewart, Alex Stewart, Warren Stewart, Orilla Stewart, and Mable Stewart. (Courtesy of Natalie Morgan.)

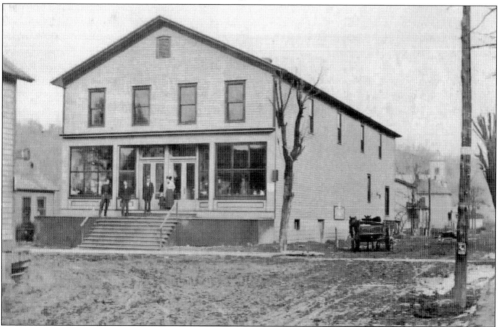

The Sullivan General Store, pictured here in 1915, was at one point the largest general store in Mason County. By 1921, the clientele of the store grew to include many people throughout the county. At one point, Sullivan's General Store claimed to have 600 customers visit its store in one day, an almost unheard-of feat for a small-town store. (Courtesy of Juanita Burdette.)

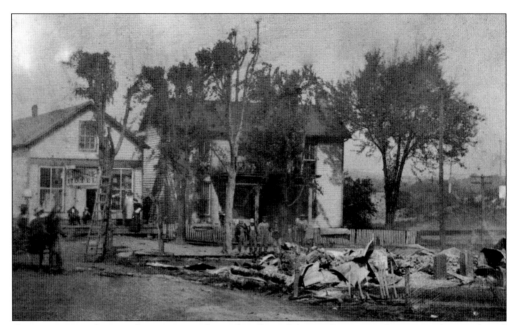

A common trend among businesses in the earlier days of the modern era is destruction by accidental fire. Sullivan's General Store had the misfortune of incurring two fires from separate iterations of its business, though both infernos occurred more than 30 years apart from one another. One fire (above) happened on May 28, 1910, when the store was still relatively new. Despite the setback, Sullivan managed to rebuild, and the store thrived afterward. The Sullivan General Store was not so lucky the next time a fire rolled through the building (below). In March 1947, the Sullivan General Store burned again, and the store never returned to its former glory. (Both courtesy of Juanita Burdette.)

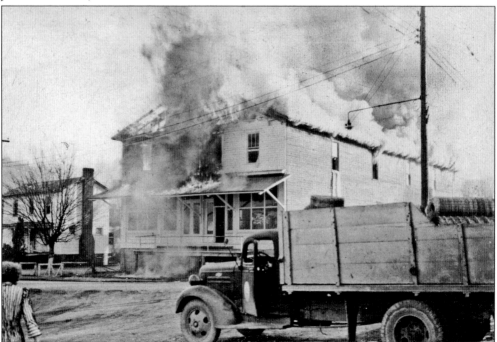

# *Three*

# WHERE THE RIVER BENDS

Along the northern part of Mason County, the Ohio River takes a dramatic turn, both in a geographical sense and in a cultural sense. The river's geographical turn is unique along its route, as it is one of the only points where the Ohio River flows north for a few miles, and at one point even flows east, a remarkable change from its near-constant westward momentum.

Not surprisingly, this area is a unique landscape for Mason County, a region unlike the rest of the county, and the river is a reflection of this marked change. The River Bend area, as this location is known, is a historically volatile and vibrant region of the county, prone to massive population fluctuation and industrial infrastructures. Though the River Bend area is in many ways tied to the Ohio River, the true feature of this region is its fertile hills and steep cliffs, which at one point were filled to the brim with salt and coal. Unlike the Kanawha River towns and the southern Ohio River cities, the communities that erupted in the River Bend area were tied to the land just as much as to the water.

Three main cities emerged in the middle of the 19th century as the need for coal and salt rose throughout the country. Mason, Hartford, and New Haven were all cities with heavy interest in the nearby hills, their fortunes connected to the output and virility provided by the land. When the offerings from the riverbanks and coal mines were plentiful, these cities flourished and thrived; when the mines dried up or the salt evaporated, the towns shrank and contracted. For decades, the area experienced this behavior, the people and their surroundings in a constant give and take, until, by the start of the 20th century, the land won out and the people began to leave. Though the area is not as vibrant as it once was, its communities were nonetheless important features of the county, a place going a different direction, the Ohio River mirroring its population in kind.

The first Letart Post Office was opened in 1840, a few years after the settlement of the area. For many years, this post office was a slow operation, with mail arriving by boat one day and leaving the post office by boat the next. (Courtesy of the Point Pleasant Post Office.)

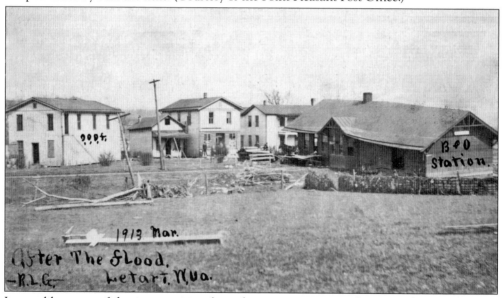

Letart, like many of the communities along the rivers, experienced massive damage from the floods tearing through the Ohio River Valley in 1913. This picture, taken shortly after the worst of the 1913 flood, portrays some of the damage dealt to the town, particularly to the B&O depot (right), Blessing's General Store (center), and the Odd Fellows Lodge (left). (Courtesy of Bob Keathley.)

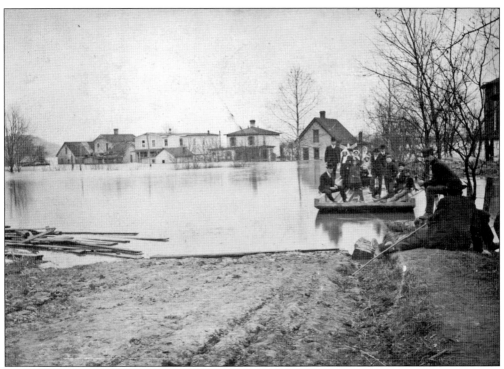

The town of Letart was founded across the river from Letart Falls, Ohio, named after an early French explorer to the region. Though it is known for this geographical feature, Letart is also situated on the banks of the Ohio River, near the edge of the Mason County border and the upturn of the Ohio River Bend area. A small community in its own right, the town was particularly susceptible to the raging floodwaters of its fickle waterways, as is evidenced by these photographs of the 1907 flood (above) and the 1937 flood (below). While the Ohio River hit a record high flood stage in 1937, the 1907 flood was a milder one, reaching 52.2 feet at its highest level. (Both courtesy of Bob Keathley.)

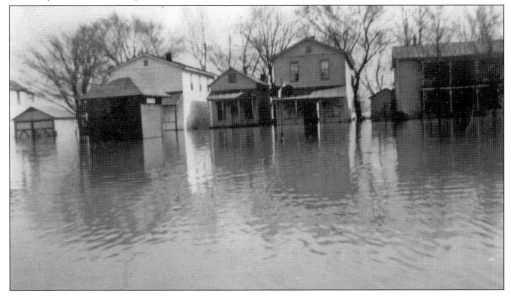

The photograph above, taken by Neal Davis in 1940, portrays some of the members of Letart. These people are members of the Hoffman, Davis, and Green family, and this photograph was taken at the Hoffmans' home in Letart, around the Tomlinson Run area of the town. (Courtesy of Bob Keathley.)

The railroad was an important part of the community of Letart, particularly the rail lines of the B&O. Members of a railroad repair team based in Letart take a break from work to pose for a picture. The men in this picture are, from left to right, Glenn Hoffman, Dewey Lyons, John Blessing, Rasler Shirley, and Bob Gibbs. (Courtesy of Bob Keathley.).

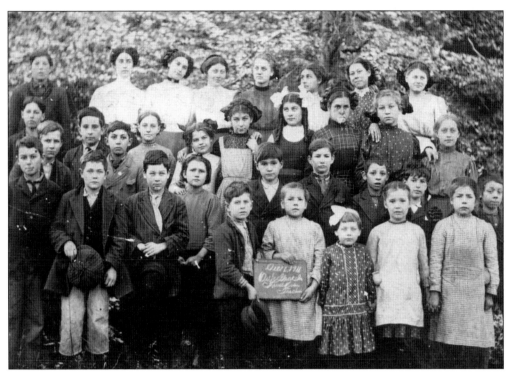

The Oak Grove School was one of the many one-room school buildings in Mason County. This picture is of the school's c. 1911 class. The teacher for this school, which incorporated children from many different grades into one classroom, was Forrest Eden. (Courtesy of Bob Keathley.)

The community of the Vernon United Methodist Church meets in front of their building during the 1880s. This church, built in 1883, was founded and organized by Rev. W. H. Diddle and originally met in the Vernon School. Though a small organization (its membership in 1986 was 28), the church is one of the oldest extent buildings in the River Bend area. (Courtesy of Bob Keathley.)

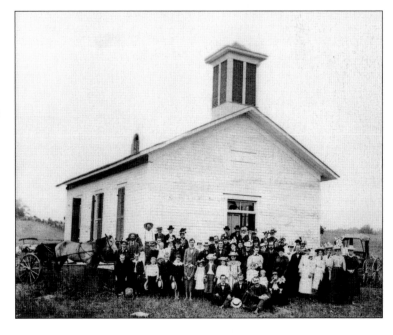

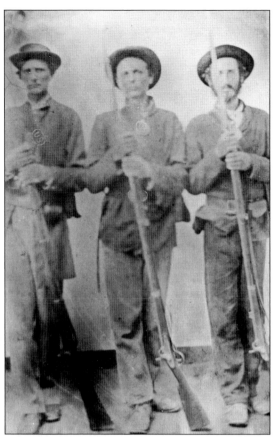

The Fry brothers were some of the soldiers who represented Mason County during the Civil War. These brothers, sons of Peter Fry and originally from the community of Longdale, fought for the Union during the Civil War. Mason County was a border county and, though technically a part of the Union, there were still many families and communities that had sympathies with the Confederates. (Courtesy of Bob Keathley.)

Another photograph of a flood in Letart portrays more of the damage wrought by the river's increased waters. Of particular note are the major buildings partially underwater in this flood, including the B&O depot, the Oak Grimm hotel, and Polsley's General Store. (Courtesy of Bob Keathley.)

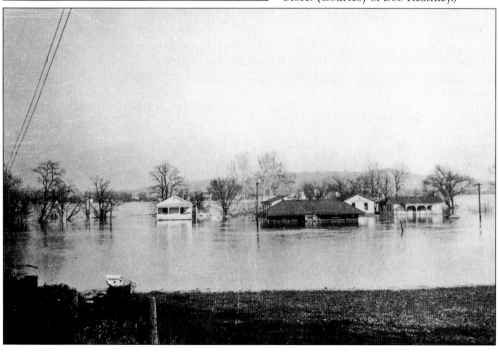

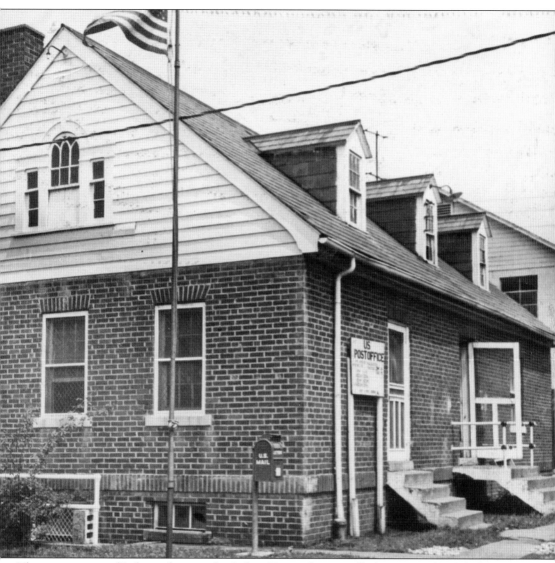

The community of Lakin is host to the Lakin Hospital, originally known as the Lakin State Hospital for the Colored Insane. The facility was an inpatient treatment center that opened in 1926. For the next 30 years, Lakin was one of the only state mental health facilities for West Virginia's black population, and the hospital maintained an all-black staff to accommodate this service. For most of these 30 years, the Lakin State Hospital was a self-sufficient enterprise, creating a tiny community unto itself in the heart of Mason County. Many of the patients in the facility were lifelong residents, their diagnoses calling for extended stay for treatment of chronic psychological afflictions. By the 1960s and 1970s, the hospital changed their practice to accommodate the changing times, and the hospital changed much of their policies regarding patient commitment terms, psychiatric treatment techniques, and long-term care facilities. Within half a century, from the 1950s to the early 21st century, the population of the Lakin Hospital shrank by 75 percent, from 400 residents in 1953 to about 114 residents in 2004. The Lakin Post Office is shown here. (Courtesy of Point Pleasant Post Office.)

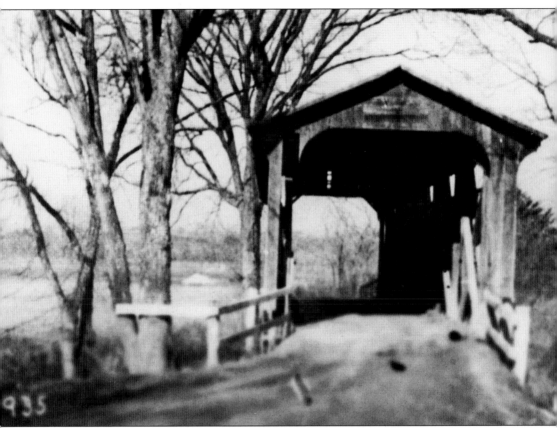

Old Town Creek is one of the many streams and tributaries found throughout Mason County. Old Town Creek and its connecting streams flow for about 17 miles, running directly into the Ohio River about 2.5 miles north of Point Pleasant. The Shawnee Indians formed a town at the mouth of this creek. Deeper into the heart of Mason County, this creek formation enters the McClintic Wildlife Management Area. Formerly the site of a World War II munitions plant, known locally as the TNT area, the wildlife management area is now a protected wildlife habitat. Much of the land outside of the Ohio River and Kanawha River is a combination of natural landscapes, farms, and other pastoral settings knitted together with ribbons of creek. For Old Town Creek and the McClintic Wildlife Management Area, these languid settings belie the history of the county, as the progression of time shows industry turning back to agriculture, a timeless struggle between nature and technology. (Courtesy of Bob Keathley.)

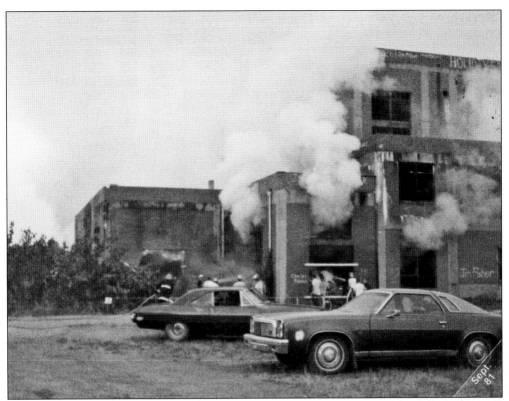

In 1966–1967, the TNT area was host to a local legend known as the Mothman. The area, now known as the McClintic Wildlife Management Area, was home to miles of industrialized munitions factories. Twenty years after the TNT closed, many of the buildings and storage facilities lay dormant, overgrown with foliage. The Mothman was first spotted in this area, particularly in the North Power Plant. For 13 months, the legend of this monster grew. When the Silver Bridge collapsed in December 1967, the Mothman was no longer seen in Mason County. On August 15, 1981, the North Power Plant burned, the clues to the Mothman's mystery forever lost in the ashes. (Both courtesy of Roger and Twila Clark.)

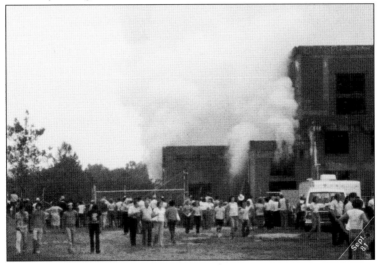

Hartford was founded in 1853 by George Moredock, a representative of the Mason County Mining and Manufacturing Company, who named the town in honor of the company's home city, Hartford, Connecticut. The town is located on land originally deeded to Col. Andrew Waggener, one of the early pioneers of Mason County. (Courtesy of Bob Keathley.)

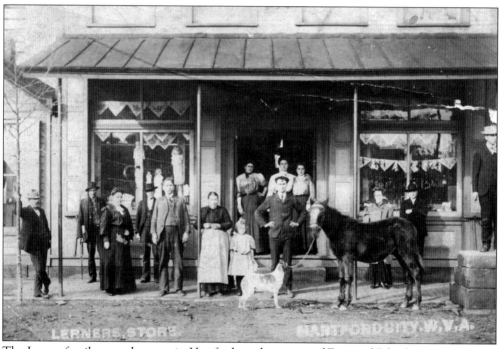

The Lerner family owned a store in Hartford on the corner of First and Pike Streets some time in the 1880s. Bernhardt J. Lerner, the owner of the store, was known throughout the city for his wordplay, a quirk that he utilized to enhance business in town. The family operated the store and established their home above the store's quarters. (Courtesy of Bob Keathley.)

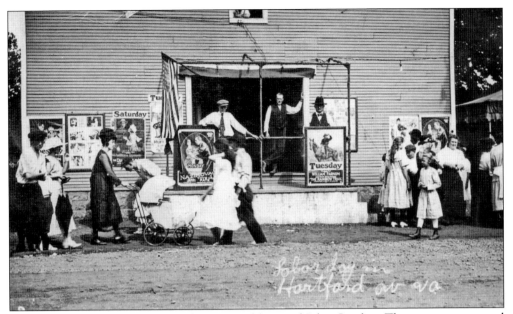

The Hartford Theatre was owned by Lewis Juhling and John Ginther. These two men turned the property, originally a skating rink, into an entertainment attraction. Serial films and other early cinema were screened there. Gail Knight (left), Juhling (center), and Ginther (right) stand in the doorway, ushering in the day's crowd. (Courtesy of Bob Keathley.)

The main sport of Hartford, West Virginia, was baseball, and the Hartford Boys, as they were known, were one of the best teams in the River Bend area. The team consisted mainly of local men who joined to play more experienced teams from around the area. In 1910, the Hartford Boys played and defeated the Cincinnati Reds, although they lost to the same team a year later. (Courtesy of Bob Keathley.)

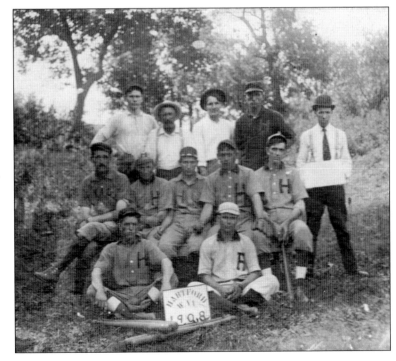

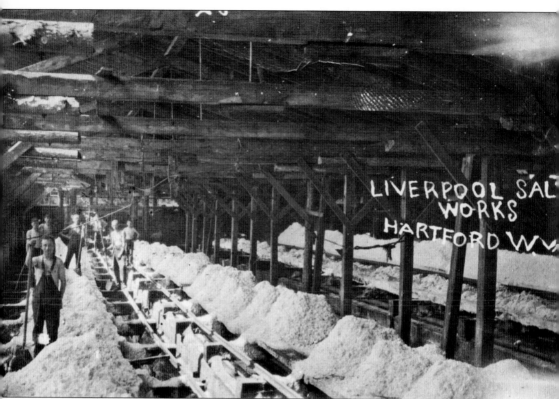

The Liverpool Salt Works, one of the largest salt works in the River Bend area, was a staple of the Hartford community. Originally called the Valley City Plant, it was located in the lower part of Hartford. For many years, the area of town around the Valley City Plant was known simply as Valley City. First incorporated in 1867, the Valley City Plant underwent a restructuring in 1878, emerging as the Aetna Salt and Coal Company. This venture was short-lived, however, as the company changed owners and became the Liverpool Salt Company. "Liverpool" was chosen as a means to attract more customers, who might assume the salt was of a similar quality to that produced in England. Though the company was named for its salt production, it also incorporated coal mining in its endeavors. The Liverpool Salt Company remained in operation until 1963. (Courtesy of Bob Keathley.)

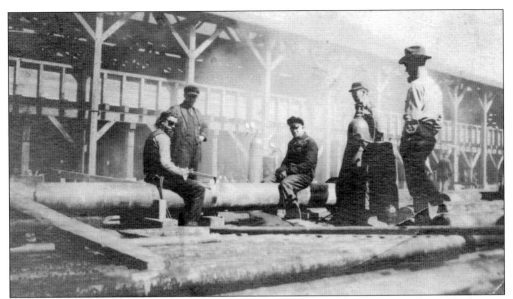

Hartford was host to other salt works and plants, such as the Hartford Salt and Coal Company and the Union Salt Company. In 1881, the Hartford Salt and Coal Company was dissolved, along with the Union Salt Company in New Haven. George Moredock, the president of both companies, endeavored to keep the salt works open, and the Hartford Salt and Coal Company remained in operation for a number of years. (Courtesy of Ortha Fields.)

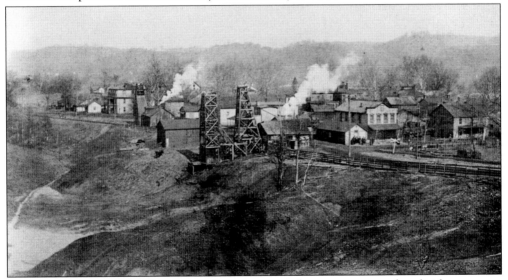

The city of Hartford is, for all intents and purposes, an industry town, created explicitly to support the industries that surrounded the city. George Moredock settled in the area in 1853 on behalf of the Mason County Mining and Manufacturing Company. Like nearby New Haven, Hartford was named after a city in Connecticut, where Moredock was originally located. Moredock was also elected the town's first mayor in 1868, the year of Hartford's incorporation. Over the years, the growth of Hartford was entirely dependent on the salt and coal companies formed in the city, with many of the residential houses being "company homes" owned by the salt works and coal companies. Once the industry died out in the first half of the 20th century, however, Hartford also faded, though it struggles onward to this day. (Courtesy of Bob Keathley.)

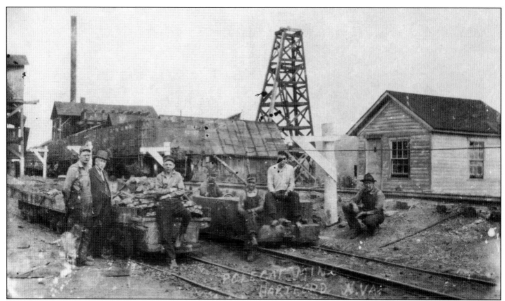

Miners from the Polecat Mine and Salt Works take a break from their jobs. The Polecat was another combination salt/mine company operated around the cities of New Haven and Hartford. The men are, from left to right, John Ray, N. E. Newton Sr., Allen Ray, Clyde B., Ted Johnson, unidentified, and John Harris. (Courtesy of Bob Keathley.)

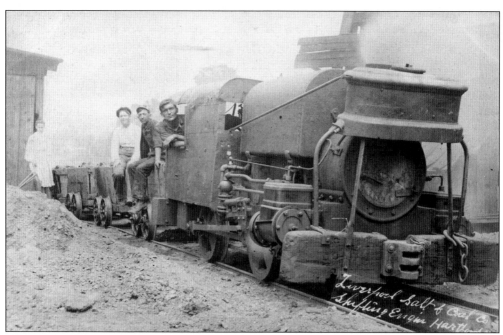

This picture, taken in 1907, depicts a shifting engine, one of the massive pieces of equipment used by the Liverpool Salt Company in Hartford. The Liverpool Salt Company used equipment such as this not only for its salt operations but also for coal mining. (Courtesy of Bob Keathley.)

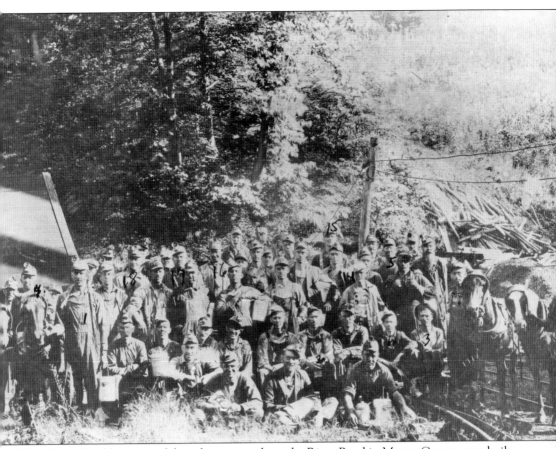

West Columbia, like many of the other towns along the River Bend in Mason County, was built upon the industries of salt and coal, the leading source of employment and prosperity for the communities of the area. One of these mines, known as "Tin Can Holler," focused on coal, which could be found in abundance in the hills surrounding West Columbia. Like much of West Virginia during the end of the 19th century, coal was a vital part of the identity of the area, as well as one of the leading sources of employment. Coal mining families were a common feature of the community, as many generations would work side by side in the coal mines and accompanying railroad lines and towboats, the fossil fuel being the heart and soul of a community like West Columbia. Some of the families found in this photograph include the Knapp, Van Meter, Lewis, and Young families. (Courtesy of Bob Keathley.)

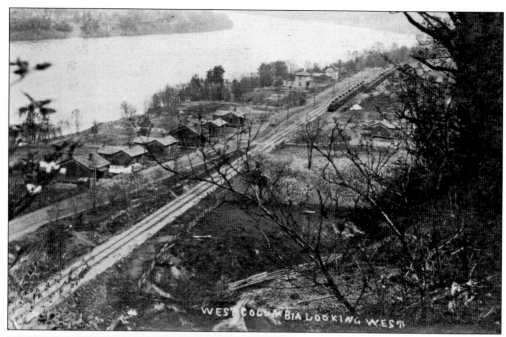

WEST COLUMBIA LOOKING WEST

The first post office in West Columbia was established in 1847. The area, founded by three families near Ice Creek Hollow, became the first in the River Bend area to produce salt. By 1851, West Columbia was the largest town in the county, with nearly 800 people in residence. The town's growth was short-lived, however, and by the end of the Civil War, the population of the area had shrunk dramatically. By 1908, West Columbia (above) was a single stretch of residences and town buildings, a survivor struggling amid the other, booming towns in the River Bend area. (Both courtesy of Bob Keathley.)

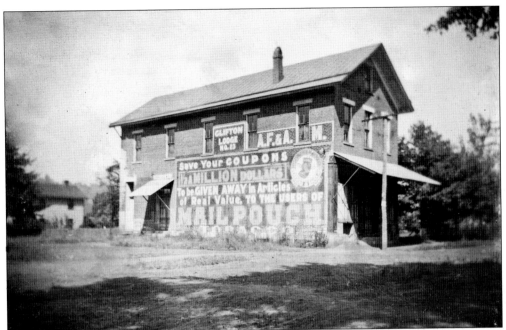

Clifton, like many of the towns in the River Bend area, was an "old salt" town, formed primarily around the coal mines and salt works that were prevalent in the area. The town was named after the many steep cliffs surrounding it. The Clifton school (below, background) was built in 1874 with the help of the Masonic lodge (above), which held meetings on the top floor of the building. The town of Clifton, though it never reached the size of its neighbors, was nonetheless prominent among the River Bend towns, hosting as many as four salt companies. Clifton experienced some heavy misfortune in 1893, however, when soot from a nearby battery set the town ablaze. Within a short time, three quarters of Clifton was on fire. The town never fully recovered from this incident. (Both courtesy of Bob Keathley.)

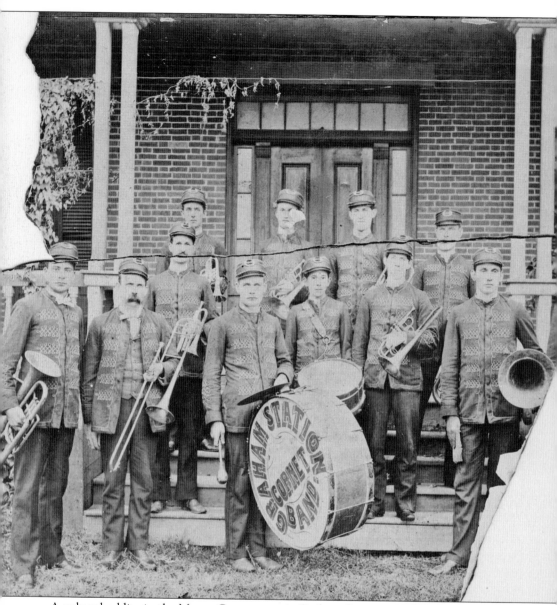

A cultural oddity in the Mason County area is Graham Station, nestled along the Ohio River between New Haven, West Virginia, and the long expanse of hills and fields to Longdale and Letart. This community was never a town proper, though Graham Station has managed to survive as a community and group for over 200 years. Formed in 1797 by the Reverend William Graham, the community existed for a short time until the death of its leader in 1799. After that incident, the land was disputed and sold by other pioneers of the area, particularly Michael Seagrist and John Roush. However, even though the community of Graham Station did not last very long, its spirit and tradition persisted, and its residents maintained their identity and connection to the area, as this cornet band from Graham Station demonstrates around the dawn of the 20th century. (Courtesy of Bob Keathley.)

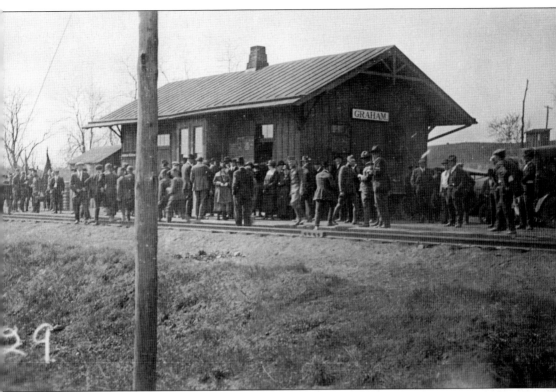

The Reverend William Graham started his settlement in 1797 as a way of creating a Presbyterian colony to attract other followers from his faith into his "station," or homogenous religious community. Graham Station was, in essence, a land designed as a safe haven for Presbyterians to live and thrive with their ideals and beliefs completely intact. Upon forming his station, Reverend Graham invited a number of families to stay and establish themselves in the settlement, the area around the River Bend being very open and removed from other settlements. In 1799, Reverend Graham traveled to Richmond, Virginia, on business, and while there, he died of illness. Without their leader, the Graham Station colony unraveled, and the land was divided between Graham's heirs, who sold the land away. Graham Station lived on, however, and the area around it is still known as Graham district, his legacy moving forward long after his experiment dissolved into the lands of Mason County. (Courtesy of Bob Keathley.)

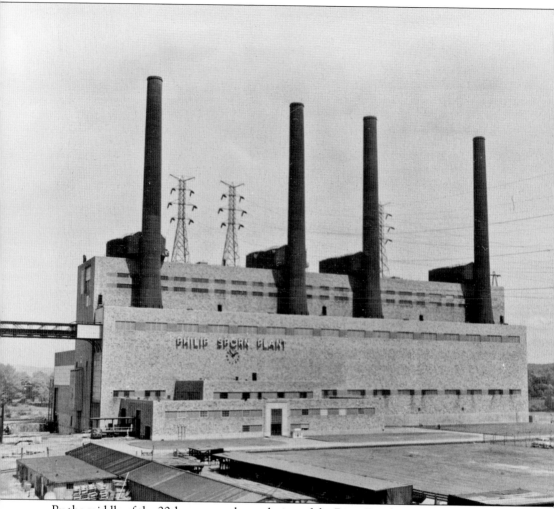

By the middle of the 20th century, the evolution of the River Bend's economy resulted in a move from coal mining and salt furnaces to larger, more technological advances such as coal-burning power plants. The emphasis for towns like Mason, Hartford, and New Haven shifted away from the labor of the land and directly into processing the natural resources into power and electricity. Two coal-burning power plants emerged in the River Bend area, the Mountaineer Plant and the Sporn Plant. The Sporn Plant was built on the land of the former Graham Station, the one-time Presbyterian colony evolving into a massive compound devoted to electricity and industry. (Courtesy of Sporn Power Plant.)

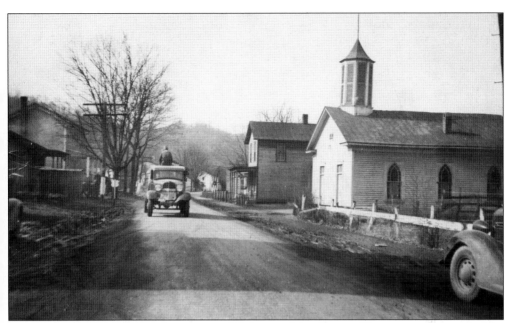

In 1938, a Fourth of July parade swings in full force in New Haven. The town was renowned for its Fourth of July celebrations, with a parade that was usually the largest in the county. Travelers from around the area would collect in the streets of New Haven to view the festivities. (Courtesy of Bob Keathley.)

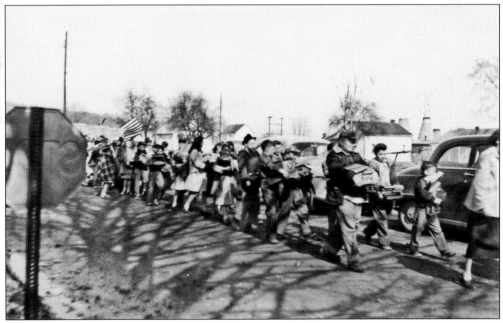

Children aid in moving their school in New Haven in the 1950s. In the early part of New Haven's history, there were no schools for the many children growing up until George Wilding Sr. decided to build one in 1859. Over the next century, many of the schools in the area were small, either one-room schoolhouses or "subscription" schools, where the parents had to pay a sum for their child to attend. (Courtesy of Bob Keathley.)

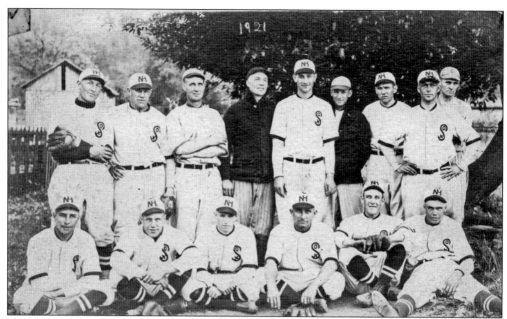

The New Haven baseball team in 1921 poses for a team photograph (above). The team members are, from left to right, (first row) Napper Roush, Harry Layne, Peck Zerkle, Howard Cundiff ("Pickle Beans"), Babe Burris, and Ralph Grimm; (second row) Cliff Roush, Herman Layne, Oscar Grimm (manager), Harry C. Grimm, Lem Ruttence, unidentified, Bill Sayre, Otto Grimm, and Pete Condiff. The 1934 New Haven team is also pictured. The batter is Will Powell, and the umpire is Lawrence Powell. Written on the postcard is a brief account of the game: "The starting of the rally which ended the game in an argument. Powell at bat hits 2 bagger scoring Miller from second tieing score nobody down in 9th. Boy oh boy." (Above courtesy of Ortha Fields; below courtesy of Bob Keathley.)

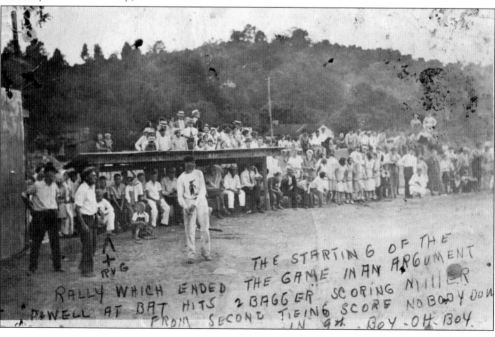

The first New Haven Post Office was established in 1864, about eight years after the formation of the town. New Haven as a community was born out of the Mason County Mining and Manufacturing Company, which, while based in Connecticut, was chartered in Virginia. This mining company purchased the land around New Haven for its access to the surrounding hills, which had very bounteous coal deposits. By 1880, New Haven had a modest population of 541 people, mostly miners and their families. Although the town is named after the city in Connecticut (like nearby Hartford, West Virginia), other names considered for the area were Gabbert's Mill, Upper Slope, and New London. (Both courtesy of Point Pleasant Post Office.)

The town of Mason, West Virginia, was created in 1852 in an effort to form a coal mining community around the hills surrounding the Ohio River. Like the nearby cities of Hartford and New Haven, Mason quickly became a city devoted to its natural resources. The first post office in Mason was established in 1856, when the city was incorporated. Like Mason County, Mason City is named after George Mason, the author of the state of Virginia's constitution. (Courtesy of Point Pleasant Post Office.)

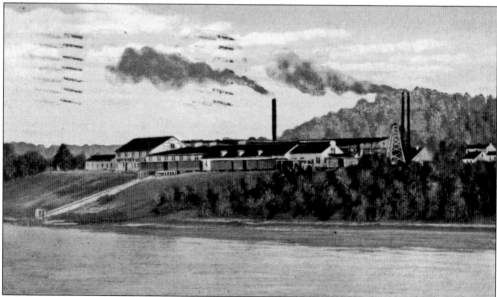

Besides coal, Mason's major industry was based in another local, natural resource: salt. Salt works sprang up around Mason shortly after the town's founding. The Ohio River Salt Company, shown in this postcard, was one such company, using the rich salt deposits found throughout the land to produce its salt. (Courtesy of Bob Keathley.)

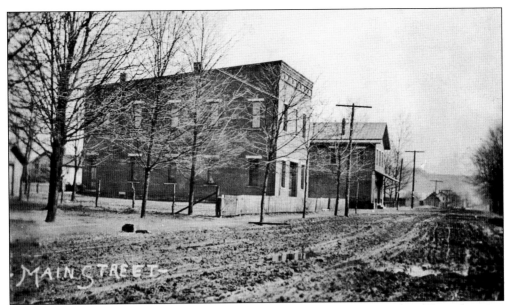

Mason City was one of the most populous cities in Mason County, especially in the years following the Civil War. By 1870, Mason had a population of 1,182; ten years later, that population had nearly doubled. Around the beginning of the 20th century, the population of the city stabilized, and the town's biggest boom was behind it. Though industry surrounded it, Mason City remained quiet, a small town with large surroundings. Main Street of Mason reflected this situation. With most of the business handled by the factories and mines outside of the city, the city's Main Street contained itself to a modest size, a perfect reflection of the town in stasis. (Both courtesy of Bob Keathley.)

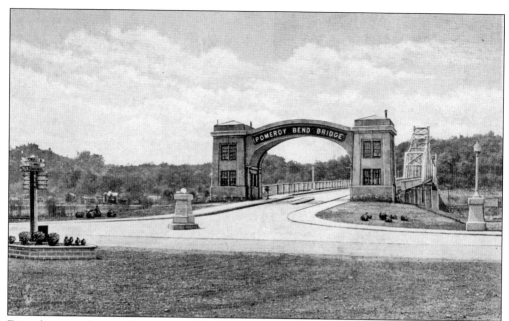

Directly across the river from Mason lies Pomeroy, Ohio. Much like its sister city across the river, Pomeroy grew out of the need for coal and other industries. The Ohio River, being the border between West Virginia and Ohio, does not truly hamper the interdependencies of cites such as Mason and Pomeroy, whose growth and development coincided despite the river and the state line. (Courtesy of Bob Keathley.)

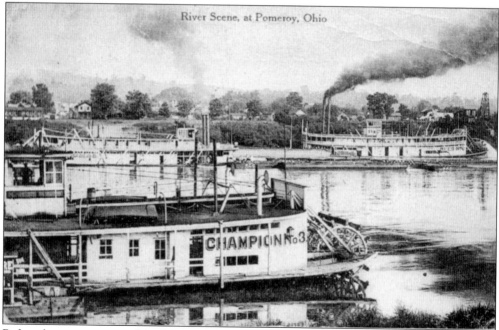

Before the construction of the Mason-Pomeroy Bridge, ferries such as the *Champion No. 3* were the main source of travel across the Ohio River. This particular ferry, the third in a string of *Champion* ferryboats, was constructed by the Mees brothers. The captain of the *Champion No. 3* was Capt. Dorr DeWolf, who piloted the ferry for 15 years. (Courtesy of Bob Keathley.)

The Winton Mine was one of many coal mines in the River Bend area. This picture, taken in 1910, shows part of the coal mining operation found within this coal reservoir. While salt was the bigger and booming business in the River Bend area, coal quickly escalated, and many of the salt companies also had coal mines under their operational umbrella. After a short time, the two industries were practically inseparable, as mineable salt was found to be a lucrative endeavor. (Courtesy of Bob Keathley.)

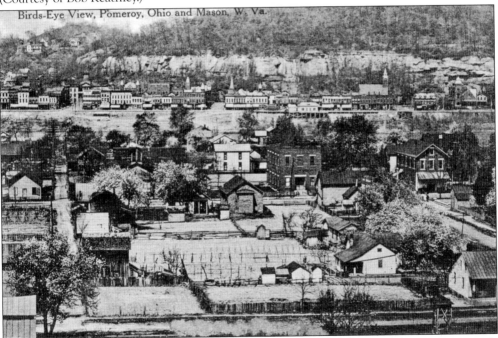

This postcard, made in 1912, portrays the close proximity between Mason and Pomeroy, not only in location but in economics, culture, and industry. Though Pomeroy's rise was more prominent and pronounced than its West Virginia corollary, the two towns established themselves and blossomed in very similar arcs. Growing up across the river from each other, Pomeroy's influence was as integral to Mason City as any other part of Mason County. (Courtesy of Bob Keathley.)

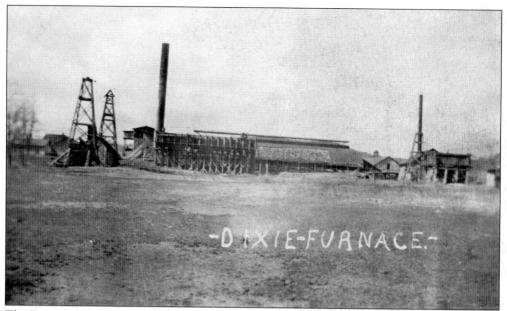

The Dixie Salt Works was one of the salt furnaces found in Mason. Though it was a booming business at the time, salt was also an unstable one, and the livelihood of the towns around the salt furnaces was almost entirely dependent on the fortunes of the salt industry. (Courtesy of Bob Keathley.)

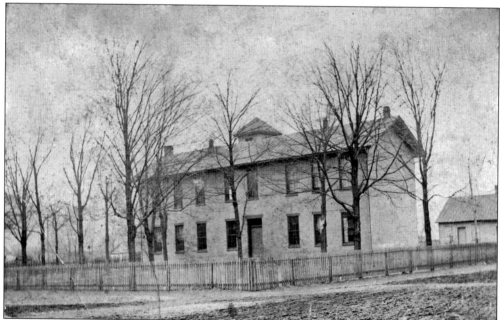

Unlike the river towns along the Kanawha River, the cities and communities in the River Bend area had much larger populations and infrastructures, and this disparity can be seen in the size of their schools. While the Kanawha River towns had their one-room school buildings, Mason City and the other River Bend cities could accommodate much larger class sizes and bigger buildings. The buildings themselves were often larger and sturdier, comprised of brick and mortar rather than logs or lumber. (Courtesy of Bob Keathley.)

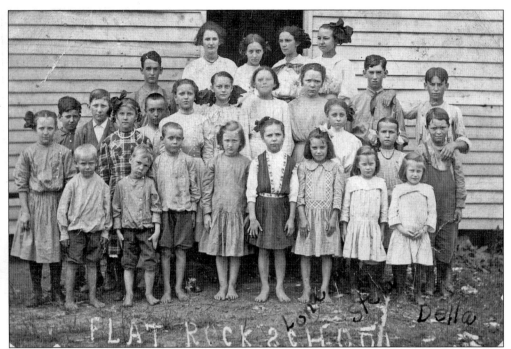

Children at Flat Rock School pose for their class picture in two consecutive years. The class of 1910–1911 (below) is, from left to right, as follows: (first row) Kenneth Love, Freda Machir, Bryon Pullin, Freda Greer, Gaynell Daugherty, Lona Fridley, Della Fridley, Stella Fridley, John Machir, and Ethel Adkins; (second row) Everett Greer, Oris Adkins, Charley Daugherty, Sidney Boggess, Lottie Machir, Gladys Pullin, Creed Pullin, Zelma Adkins, and Horton Greer; (third row) Ancil Rice, Will McKinney, Homer Riffle, Ona Pullin, Sybil Boggess, Growe Daugherty, Elmer Riffle, and Fred M. Roush; (fourth row) Hoy Pullin and Glen Boggess. Because of the school's small size, many children from the same family and in multiple grades would share the same teacher and classroom, a typical feature of one-room schools of the time. (Both courtesy of Karen Fridley.)

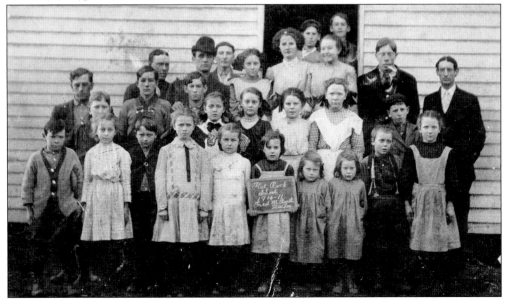

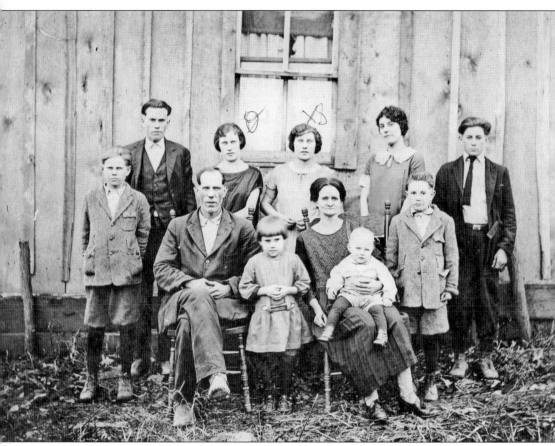

The Fridley family poses for a portrait. This picture, taken on November 29, 1925, shows the family on their farm in Flat Rock, West Virginia. Flat Rock was a small community in the middle of Mason County, and the Fridleys were one of the prominent families of the town, living on a 75-acre farm near Flat Rock. A cousin of the Fridleys, Dr. Preston Love, was a physician in town. Taylor Nimrod Fridley (first row, far left) lived to the age of 90. His daughter, Lona Fridley, was a longtime schoolteacher throughout Mason County as well as an author and historian. (Courtesy of Karen Fridley.)

# Four

# A Pleasant Point and Below

The southern half of the Ohio River in Mason County is an amalgamation of the disparate features of Mason County. Starting at Tu-Endie-Wei, the confluence of the Ohio and Kanawha Rivers, and moving south from Point Pleasant and Henderson to Gallipolis Ferry, Apple Grove, and Glenwood, this southern part of the county is, in many ways, a pure combination of the areas already described. From the small, quiet river towns, to the boom and bust of the River Bend, to the utilization and supplication to the rivers, this chapter describes the core of Mason County in theme and geography.

Point Pleasant's history and culture is not a coincidence in the grander scheme of Mason County. Historically, the town is the oldest in the county, though it did not hit its major growth spurt until much later than the other towns. Culturally, it is a bustling city among many smaller towns, a locus of business and industry not seen elsewhere in the area. As it is at the nexus of the rivers, the very crux where the other areas of the county meet, it is bound to share the characteristics that surround it. All roads—and all rivers—flow to Point Pleasant, and its influence seeps into the southern part of the county.

Through history or geography, the culmination of Mason County's regional themes is located, in some fashion, where the waters meet. When the population of the River Bend reached its peak and started to contract, the population of Point Pleasant expanded. When the river industry began to bustle, Point Pleasant led the charge. When smaller towns emerged as supplemental communities along the rivers, the southern half of Mason County blossomed. Thus, as the Ohio flows south and the Kanawha flows west, their convergence leads to the mingling of the waters at Point Pleasant and continues southward, until it carries the county's essence beyond the county line.

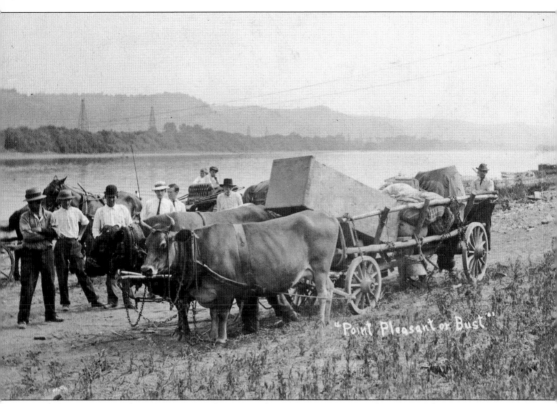

The motto listed on this postcard, "Point Pleasant or Bust," is indicative of the importance of this city to the history and development of Mason County. Though it was the first settlement in the county, founded in 1794, the city was not incorporated until much later, 1833. For much of the 19th century, Point Pleasant's growth was steady but not as strenuous as cities in the northern part of the county, particularly Mason, New Haven, and Hartford. In 1880, the population of Point Pleasant was 1,007 people, compared to Mason City (2,014) and Hartford (1,162). By the turn of the century, however, the trend reversed, with Mason City losing population and Point Pleasant gaining. By the 1940s, Point Pleasant's population reached nearly 4,000, while Mason's stagnated. Thus the rush to Point Pleasant began around the dawn of the 20th century. (Courtesy of Mike Brown.)

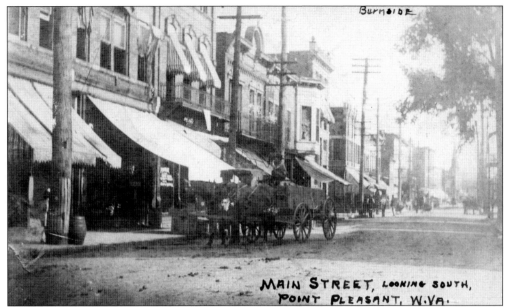

MAIN STREET, looking south, POINT PLEASANT, W.VA.

Main Street of Point Pleasant is the central hub of the city, stretching for blocks along the Ohio River. At one end is Tu-Endie-Wei, where the monument to the Battle of Point Pleasant is located. At the other end is the Mason County Courthouse. This area is the nexus of Point Pleasant's downtown, the largest commercial center in Mason County. These pictures portray Point Pleasant in two time periods. The first (above) is during the initial boom of the city, around 1908. Colorful awnings jut into the street, inviting customers into their shade. By the 1950s (below), the awnings are gone, but the businesses are not. The heyday of Point Pleasant can be found in this decade, when growth of the city hit its stride. Businesses such as G. C. Murphy's and the Lowe Hotel formed the cornerstone of the downtown economy, bolstered by the growing population around the city. (Both courtesy of Mike Brown.)

Successful cities enjoy lavish parties, and while Point Pleasant's commercial and political success expanded rapidly and with great momentum, the frequency of its parades also increased. The tall buildings and looming structures lining the streets create an exquisite backdrop for marching bands, floats, and other revelers as they make their way down the rows of businesses and residences on their way to Tu-Endie-Wei. As the years wore on, the parades increased in attendance and joviality, their frivolity reaching their peak in the middle of the 20th century. However, as the years dragged on and the business died, so too did the parades. As Point Pleasant's business district fell apart after the Silver Bridge collapsed, the merrymaking fell to quieter levels, though it never left completely. (Both courtesy of Bob Keathley.)

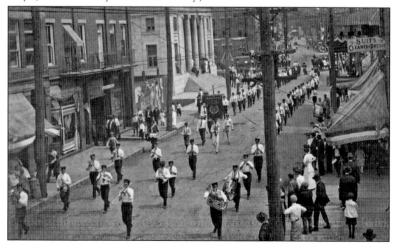

ADEMY AT POINT PLEASANT, W. VA.—GREETINGS

Built in the shadow of the Mason County Courthouse, Central Grade School was one of the biggest elementary schools in Mason County. The two-story brick building was constructed in 1890 at a cost of $20,000. The school contained eight rooms and a library, a rather large structure compared to the numerous one-room school buildings strewn throughout the county. One distinguishing feature of the school was its bell, which hung in a bell tower atop the building and was drawn by a pull string. Children from around the town could hear the bell ring, echoing through the streets and beckoning the children to their studies. Central Grade School was demolished in the 1970s, replaced by the Mason County Library. (Courtesy of Mike Brown.)

The largest and most impressive building in the city of Point Pleasant was the Spencer Hotel, a towering structure in the heart of downtown Point Pleasant. Constructed in 1904 by the Mutual Realty Company of Point Pleasant, the building was named in honor of John Samuel Spencer, a well-known and respected lawyer, investor, and businessman. The hotel had some of the more ornate furnishings on the Ohio River, and its luxury was known to ship captains and dignitaries alike. The hotel hosted many businesses on its first floor, including banks, barbershops, and even Point Pleasant's city hall at one time. Eventually the Spencer Hotel changed hands and was renamed the Lowe Hotel, though it never reduced in quality or grandeur. (Courtesy of Mike Brown.)

Point Pleasant has had a post office in some form since 1805. The current post office, shown here, was built in 1912–1913. The post office was completed around the time of the 1913 flood, an ominous distinction. Floodwaters reached their highest point in Point Pleasant's history, and the flood was high enough to reach the new building's main desk, located on the second floor of the building. For most floods, the post office was safe, save the 1937 flood, which tied the record set by the 1913 flood. In the early years of the post office, mail was dispatched to and from six trains on the Kanawha and Michigan rail line, then the most prominent rail in the area. The post office remains in the same building to this day, nearly a century after its construction. (Courtesy of Mike Brown.)

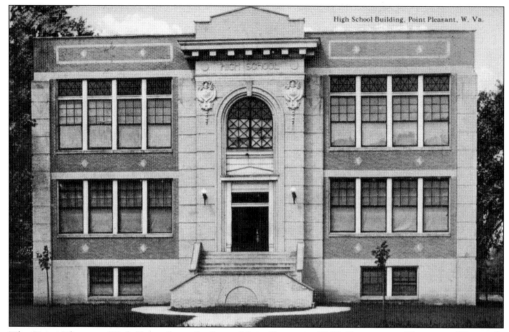

High School Building, Point Pleasant, W. Va.

The Point Pleasant High School was built on Main Street in 1917. Constructed between Eleventh and Twelfth Streets, it would later serve as a junior high school and be renamed the Central School (not to be confused with the former Central Grade School on Sixth Street). Another junior high school was built in 1936–1937 as well. Both junior high school buildings are still standing to this day. (Courtesy of Bob Keathley.)

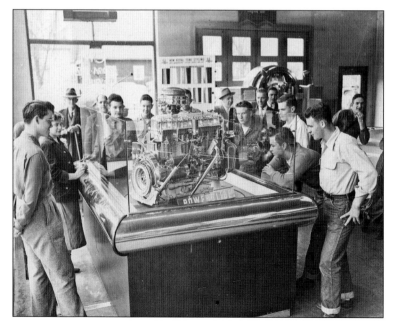

Mason County Motor Company was a car dealership and auto repair station near Point Pleasant's downtown area for many years in the middle of the 20th century. The general manager of Mason County Motor Company was William Rupert Knight, who looked over the business from 1954 to 1979. (Courtesy of Bob Keathley.)

The first church built in Point Pleasant was organized and constructed in 1834 by Rev. Francis Dutton. Before this time, many Presbyterians held service across the river in Gallipolis, Ohio. Though this church and its organization underwent numerous iterations and restructuring, its community has lasted for over 170 years. (Courtesy of Bob Keathley.)

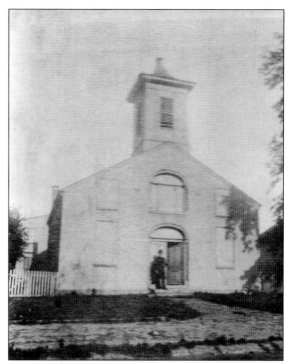

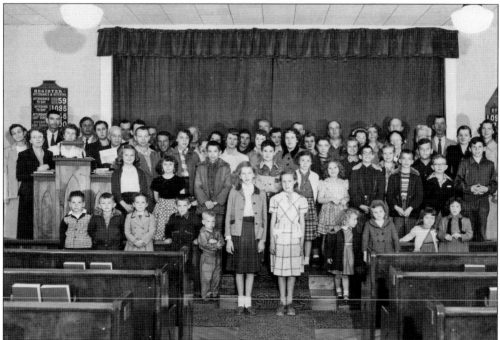

The Hickory Chapel Methodist Church, located just outside the borders of Point Pleasant, is one of many Methodist churches in Mason County. Like the one-room schools that dotted the countryside, churches such as the Hickory Chapel often had small, local, and loyal congregations. The Methodist faith, being one of the more popular denominations in Mason County, naturally had a higher number of smaller congregations as well. (Courtesy of Arnolda Carpenter.)

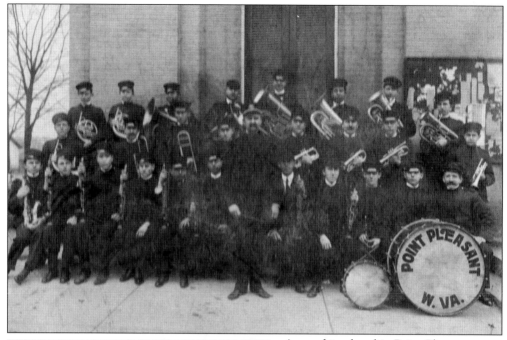

A marching band in Point Pleasant poses for a group photograph. Accompanying many of the parades and festivals held in the city were bands such as these, usually based in the local high schools and social clubs in the surrounding county. When there was cause for celebration, a Point Pleasant marching band would almost always be near at hand. (Courtesy of Bob Keathley.)

The Fridley children frolic near the mouth of Old Town Creek in Point Pleasant. Old Town Creek flowed into the river just north of Point Pleasant. The creek flowed through Old Town Farm, owned by members of the Lewis family, whose ancestors led the Virginia militia at the Battle of Point Pleasant. (Courtesy of Karen Fridley.)

William Jennings Bryan (rear of vehicle, left side) visits Point Pleasant around 1920 during a political campaign. Bryan, one of the nation's longtime, venerable politicians, visited Mason County on behalf of his brother, Charles Wayland Bryan, who was also campaigning for political office. Capt. Pearl T. Burdett is driving the vehicle. Bryan gave a speech that day at the Mason County Courthouse. (Courtesy of Bob Keathley.)

Officials stand in front of the first Mason County Courthouse in the first part of the 20th century. The original courthouse was built in the 1850s and served until a century later, when the current Mason County Courthouse was constructed. History was not always kind to the courthouse, offering floods, raids, explosions, and other disasters throughout its existence. Regardless, the building endured every hardship and remained an important part of Mason County. (Courtesy of Bob Keathley.)

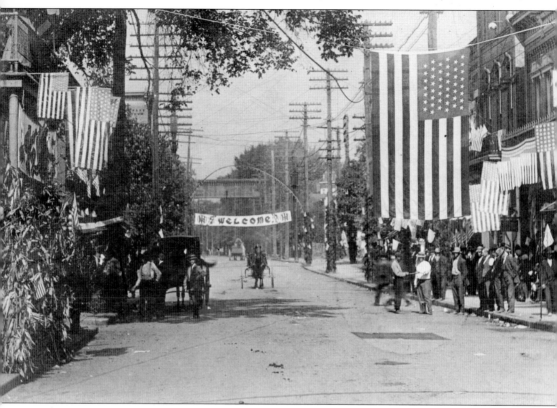

In 1909, the citizens of Mason County, led by Livia Nye Simpson-Poffenbarger, organized the funds for the creation of a monument in commemoration of the Battle of Point Pleasant. The monument was placed in Tu-Endie-Wei Park at the conjunction of the Ohio and Kanawha Rivers. On October 9, 1909, the streets of Point Pleasant were packed with thousands of people in celebration of the battle and the construction of the monument. A giant obelisk, the monument is 82 feet high and contains 152 granite blocks, totaling nearly 143 tons of commemorative stonework. The monument has remained in place for almost a century, withstanding floods, storms, and weathering throughout that time. (Courtesy of Bob Keathley.)

Draftees from Mason County line up on the Point Pleasant Post Office steps for service in World War I. In the buildup to the Great War, Mason County had 4,071 men registered for selective service in the U.S. Armed Forces; by the end of the war, the county had sent 660 overseas. Kenneth Birchfield, a citizen of Henderson, was the only soldier from Mason County to be honored for heroism in this war, receiving the Distinguished Service Cross. Another Mason County soldier, Hobert Augustus Seigrist, was awarded the Navy Cross. (Both courtesy of Bob Keathley.)

**United States Civil Service Commission,**
FOURTH CIVIL SERVICE DISTRICT,
OFFICE OF THE SECRETARY,
HEADQUARTERS, WASHINGTON, D. C.

Examinations at Washington, D. C., are held at Temporary Bldg. No. 1, 18th and D Sts., NW., 18th Street Entrance; at Baltimore, in the Customhouse. For the location of examination room in other cities apply to the secretary of the board of examiners at the post office in the city or town where the examination is held.

Take to the examination room, pen, ink, pencil, and eraser (but no paper). Applicants for the typewriting, bookkeeping, drafting, or other examination requiring the use of machines or implements, must furnish such machines or implements for use during the examination. Typewriter machines and tables sent to the examination room must be labeled with the applicant's name and address.

Your application will be examined, and in case of disapproval you will be notified.

**DISTRICT SECRETARY.**

I certify that the attached photograph appears to be a correct likeness of the applicant.

_D. W. Buller_
Examiner.

I certify that the attached photograph appears to be a correct likeness of the appointee.

Signature _____

Official title of appointing officer _____

Unless you paste an unmounted photograph of yourself (taken within two years) within this space and present this card to the examiner, you will not be exam-

Above photograph taken _Feb 19 1921_
(Date.)

(The blanks below must be filled out in the examination room.)

Examination Number _75263_

Applicant's signature _Milton Lewis_
6—2366

---

These cards are the applications from two men for a position in the Point Pleasant Post Office. Milton Lewis (above) was born in 1899 in Beech Hill. For years, Milton was a teacher throughout the county, particularly at Hickory Chapel, just outside of Point Pleasant. Milton Lewis also moved on to serve in the State Road Commission of West Virginia. In 1948, he was chosen as chief engineer on the construction of the Point Pleasant floodwalls. Samuel Lutton (below) lived in the Heights district of Point Pleasant, which at one point hosted its own post office. (Both courtesy of Point Pleasant Post Office.)

---

**United States Civil Service Commission,**
FOURTH CIVIL SERVICE DISTRICT,
OFFICE OF THE SECRETARY,
HEADQUARTERS, WASHINGTON, D. C.

Examinations at Washington, D. C., are held at Temporary, Bldg. No. 1, 18th and D Sts. NW., 18th Street Entrance; at Baltimore, in the Customhouse. For the location of examination room in other cities apply to the secretary of the board of examiners at the post office in the city or town where the examination is held.

Take to the examination room pen, ink, pencil, and eraser (but no paper). Applicants for the typewriting, bookkeeping, drafting, or other examination requiring the use of machines or implements, must furnish such machines or implements for use during the examination. Typewriter machines and tables sent to the examination room must be labeled with the applicant's name and address.

Your application will be examined, and in case of disapproval you will be notified.

**DISTRICT SECRETARY.**

TO THE EXAMINER.—This card must be returned to the District Secretary after the examination, with report of examination on Form 1492.

I certify that the attached photograph appears to be a correct likeness of the applicant.

_R. W. Allen_
Examiner.

I certify that the attached photograph appears to be a correct likeness of the appointee.

Signature _____

Official title of appointing officer _____

Unless you paste an unmounted photograph of yourself (taken within two years) within this space and present this card to the examiner, you will not be examined. Tintypes or proofs will not be accepted.

Above photograph taken _July 11-1927_
(Date.)

(The blanks below must be filled out in the examination room.)

Examination Number _11685_

Applicant's signature _Samuel L. Lutton_
6—2366

GOVERNMENT PRINTING OFFICE

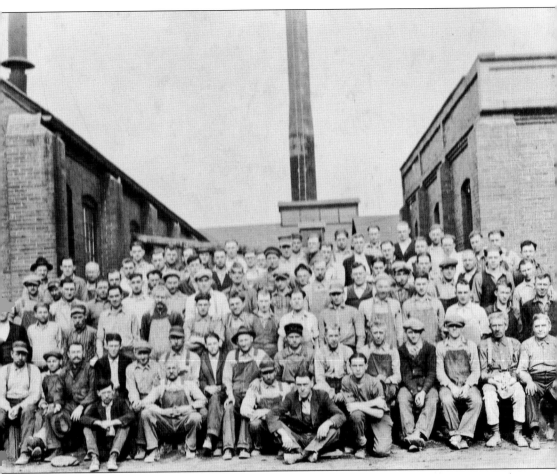

The West Virginia Malleable Iron Company was incorporated in 1902, a business venture created by three of the big local players of Point Pleasant: Homer Smith, J. S. Spencer, and Taliaferro Stribling. The plant was constructed in the Heights district, just outside of the incorporated limits of Point Pleasant and about 500 feet from the banks of the Ohio River. The Baltimore and Ohio Railroad had a sidetrack to the Malleable Iron plant that ran the length of the plant. At its peak, the Malleable Iron Company employed nearly 250 workers, focusing its efforts on producing iron castings used in automobiles, railroad engines, and farm equipment. Together with the Marietta Manufacturing Company, also located in the Heights district, the Malleable Iron Company remained a major player in the local economy until the plant discontinued operation in 1983. (Courtesy of Bob Keathley.)

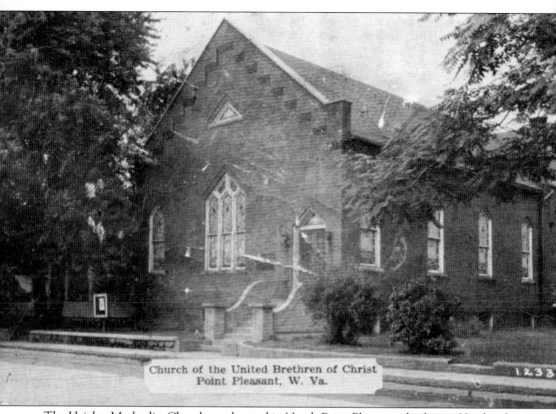

Church of the United Brethren of Christ
Point Pleasant, W. Va.

1233

The Heights Methodist Church was located in North Point Pleasant, the former Heights district of the town. The church was originally organized in 1899 by George Burdette and was known as the United Brethren Church, later changing its name to the United Methodist Church in 1968. Lutton Construction developed the first frame church on the present site and later built the present sanctuary and educational unit. Over the past century, the church has undergone many changes, with construction efforts and building renovations of some kind occurring about once every decade. When the church was first organized, its trustees were Harvey Fisher, Sam Lutton, Lewis McMillin, William Duffey, and John Schools. (Courtesy of Roger Clark.)

Garnette Workman (back) and Arnolda Workman (front) sit in an old car in the 1930s. The car, an old-fashioned Chevrolet, had to be started using a hand crank. Point Pleasant as a city was quick to adopt the automobile, and by the 1930s, it was one of the most popular modes of transportation, quickly outgrowing the traditional methods such as river and railroad travel. (Courtesy of Arnolda Carpenter.)

This picture, taken in 1942, depicts Wendell Smith posing in front of a commemorative anchor at Tu-Endie-Wei Park in Point Pleasant. Like many of his fellow citizens, Wendell served in World War II. Mason County sent hundreds of young men out to serve in that war. Businesses like the Marietta Manufacturing Company in Point Pleasant aided in the conflict by constructing ships for the war effort. (Courtesy of Arnolda Carpenter.)

Garnette Buckalew (right) and Emory Proffitt share a moment in 1931. The Proffitt family moved to the Mason County area in the 1850s. An ancestor of the Proffitts accompanied Capt. John Smith to Jamestown, Virginia, in 1607. Emory and Garnette were married in 1931. (Courtesy of Arnolda Carpenter.)

Members of the Buckalew family gather for a family portrait. The family members are, from left to right, (first row) Roy Buckalew, Strand Buckalew, Eddie Buckalew, Garnette Buckalew, and Flaura Buckalew; (second row) Ed Buckalew and William See. The Buckalews owned a farm near Hickory Chapel, outside of Point Pleasant. This picture was taken in 1910. (Courtesy of Arnolda Carpenter.)

Another generation of the Buckalew family poses for a photograph. Roy Buckalew (second row, right) worked on the railroad for a number of years around the Ohio Valley. His son, Bacyle Buckalew (first row, center) was a schoolteacher in Mason County for 39 years. (Courtesy of Arnolda Carpenter.)

Children pick cherries along Lincoln Avenue in Point Pleasant around 1935. The children are, from left to right, Bill Proffitt, Arnolda Workman, Ralph Buckalew, Edna Cox, and Helen Hughes. Besides cherries, other wild fruits were commonly found around Point Pleasant, particularly blackberries. (Courtesy of Arnolda Carpenter.)

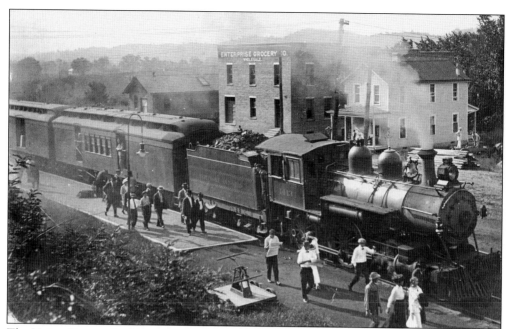

The Union Depot, also known as the Kanawha and Michigan Depot, was located on Highland Street north of Point Pleasant. Around the depot was a small group of connected businesses, including Enterprise Groceries (background, above). The depot below was built in 1885 and was used for both freight and passenger rail. Railway workers on their way through town would often stay at lodging specifically designated for railroad porters on Sixth Street, across the street from the Mason County Courthouse. The depot was in operation through much of the first half of the 20th century, though its importance to the community gradually died down. Union Depot was closed and torn down in 1958. (Above courtesy of Bob Keathley; below courtesy of Mike Brown.)

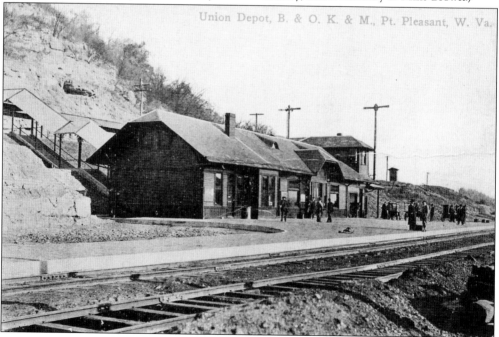

The Point Pleasant Odd Fellows Lodge No. 33 is the second attempt at establishing an Odd Fellows lodge in the city. The first lodge was started in 1855 but lasted only six years, ending at the start of the Civil War. Lodge No. 33 began after the war, in 1871, and has been situated on the corner of Main and Fourth Streets in Point Pleasant since 1900. Four other organizations from around the county merged with the Odd Fellows, including the Buffalo Temple, the Letart Evergreen, and the Leon Miriam. The two pictures shown here were taken 40 years apart from one another. The first (above), taken on February 6, 1947, is a recently initiated group; the one below is a group of longtime members on December 18, 1987. (Both courtesy of Odd Fellows Lodge No. 33.)

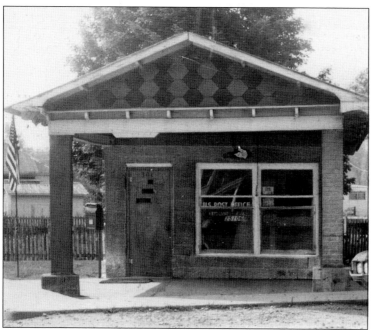

The town of Henderson is situated directly across the Kanawha River from Point Pleasant and is a small community also resting on the juncture of the Ohio and Kanawha Rivers. Henderson is named after Samuel Bruce Henderson, who owned all the land from which the town was formed. Though it was laid out in 1879, the town was not incorporated until 1893. (Courtesy of Point Pleasant Post Office.)

The Henderson School, above, was one of the few school buildings to be found in the town. Although the communities of Henderson and Point Pleasant were very closely tied together, Henderson had some independence from the larger city across the Kanawha River. This school building, however, was torn down in the late 1960s to make way for the Silver Memorial Bridge. (Courtesy of Randall Kenton Sheline.)

Roy Price was one of the many applicants to the Point Pleasant Post Office in 1928, particularly for the clerk/carrier position. Price was a resident of Henderson, and the Point Pleasant Post Office was a short ferry ride away. Many of the applicants for the post office were from the Henderson/Point Pleasant area. (Courtesy of Point Pleasant Post Office.)

Charles L. Clark Jr. (left) and Angus Robbins (right) play along the banks of the Kanawha River outside of Henderson, West Virginia, in the 1920s. The Shadle Bridge looms in the background. The river was more than a means of transportation or employment to the denizens of Mason County. Rather, the river was a ubiquitous presence in every person's life, a source of pleasure as much as industry. (Courtesy of Roger Clark.)

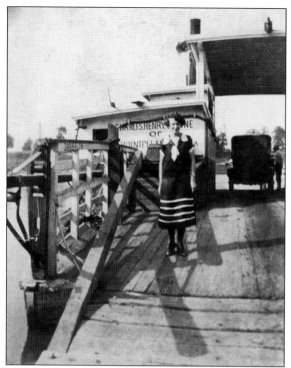

The *Charles Henry Stone* was a ferry on the Kanawha River between Point Pleasant and Henderson. The Stones operated a ferry between these two towns for nearly 50 years, from the late 19th century until the building of the Shadle Bridge in 1934. This ferryboat was a side-wheel boat, a step above the ferry flats and poled ferries often found along the river. C. C. Stone was the last of the family to operate the ferry, but his son, Charles Henry (the boat's namesake) continued the family's river tradition, becoming a well-known riverboat captain throughout the Ohio River. (Both courtesy of Roger Clark.)

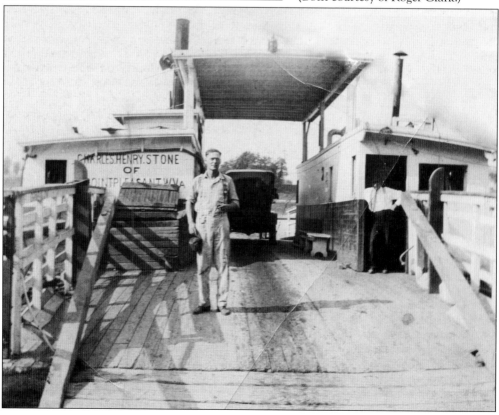

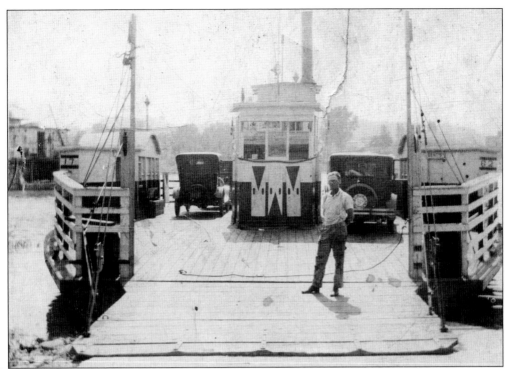

By the time the age of the automobile rolled around, ferries on the Ohio and Kanawha Rivers acted as moving bridges, growing larger and more capable of sustaining heavier traffic than their predecessors, although usually at a steeper price than normal pedestrian traffic. For instance, the price for transporting an automobile and driver across the Kanawha River on the *Charles Henry Stone* was 25¢; a pedestrian could cross the river with only a dime. (Courtesy of Roger Clark.)

Charles L. Clark Jr. works on a riverboat on the Kanawha River in the 1930s. A resident of Henderson, Charles was typical of many citizens of the town, where working on the river was one of the largest areas of employment. Most of the work was for towboats and other watercraft devoted to West Virginia's coal industry. (Courtesy of Roger Clark.)

# CALDWELL POLITICAL CHART, 1900 TO 1952

| | 1900 | 1904 | 1908 | 1912 | 1916 | 1920 | 1924 | 1928 | 1932 | 1936 | 1940 | 1944 | 1948 | 1952 |
|---|---|---|---|---|---|---|---|---|---|---|---|---|---|---|
| U. S. President | McKinley Roosevelt | Roosevelt | Taft | Wilson | Wilson | Harding | Coolidge | Hoover | Roosevelt | Roosevelt | Roosevelt | Roosevelt Truman | Truman | ? |

### Select Your President - - Pick Your Governor

| | 1900 | 1904 | 1908 | 1912 | 1916 | 1920 | 1924 | 1928 | 1932 | 1936 | 1940 | 1944 | 1948 | 1952 |
|---|---|---|---|---|---|---|---|---|---|---|---|---|---|---|
| W. Va. Governor | White | Dawson | Glasscock | Hatfield | Cornwell | Morgan | Gore | Conley | Kump | Holt | Neely | Meadows | Patteson | ? |

### Support and Vote, L. L. CALDWELL, for Assessor. *Thanks!*

| | 1900 | 1904 | 1908 | 1912 | 1916 | 1920 | 1924 | 1928 | 1932 | 1936 | 1940 | 1944 | 1948 | 1952 |
|---|---|---|---|---|---|---|---|---|---|---|---|---|---|---|
| Mason County Sheriff | Barnett | Mc-Dermot | Austin | Bletner | Ball | Lewis | Sturgeon | Burdette | Douglass | Rowsey | Lieving | Hesson | Morrison | ? |
| Mason County Assessor | Musgrave Sturgeon | Musgrave Sturgeon | Barnett | Rowsey | Beol | Burdette | Oshel | Lieving | Roush | Bletner | Morrison | Morrison | Buckle | ? |

**BE SURE YOU ARE REGISTERED** ⬧ **GO AND VOTE NOV. 4TH, 1952**

This political chart, in part serving as a campaign advertisement for Lewis Ledrew Caldwell, displays some of the political history of Mason County as well as some of the larger, national campaigns of 1952. Charles Roberts was voted as Mason County sheriff that year; Caldwell was not elected as assessor. (Courtesy of Mason County Chamber of Commerce.)

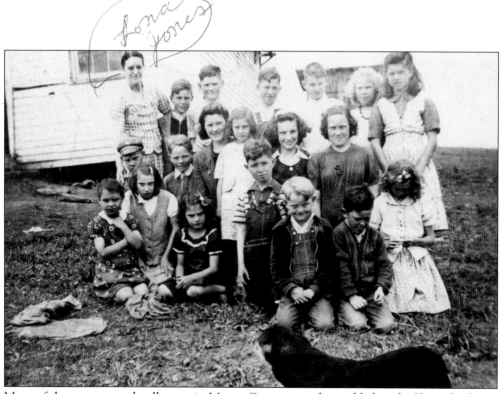

Many of the one-room schoolhouses in Mason County were located below the Kanawha River, in the small villages and communities that dotted the hills and fields of the county's southern half. Red Mud School was one such facility, serving a small neighborhood community and its children until well into the 20th century. (Courtesy of Karen Fridley.)

Gallipolis Ferry was at one point a major crossing point across the Ohio River. Early in the history of Mason County, the area around Gallipolis Ferry was a launching point for crossing the river into Gallipolis, Ohio. The ferry house was located directly across the river in the state of Ohio. Though the ferry is no more, the Gallipolis Ferry vicinity is still important to the Ohio River. The Robert C. Byrd Lock and Dam is located near the site of the former Gallipolis Ferry. Gallipolis Ferry has therefore evolved along with the river, its fortune tied directly to the need to maintain, utilize, and control the beautiful river. (Courtesy of Point Pleasant Post Office.)

The towns along the Ohio River south of Point Pleasant are some of the least populated in the county, and these villages have historically remained as such. Apple Grove, one such town in the southern half of Mason County, is located near Mercer's Bottom. Unlike the Kanawha River, which had many small, yet thriving, communities such as Leon, or the River Bend area, with the salt and coal industry to help maintain boomtowns like Mason and New Haven, this southern end of the county was never a heavily populated area at any point in Mason County's history. Apple Grove, Glenwood, and Mercers Bottom are all tiny hamlets and quiet neighborhoods devoted to the peaceful life of agriculture and the river, both of which are open and available in abundance in this area. (Courtesy of Point Pleasant Post Office.)

Glenwood, formerly known as Hannan's Landing, was originally settled in 1780 by Thomas Hannan, an early pioneer of Mason County. By 1802, Hannan had an established ferry across the Ohio River. After the Civil War, Hannan's Landing was changed to Glenwood and continued to grow, adding a railroad depot, gristmill, and other establishments to make it a thriving, though small, town. (Courtesy of Point Pleasant Post Office.)

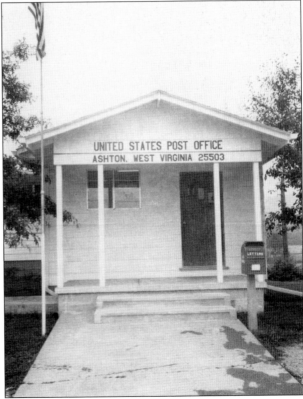

Ashton is another small community on the Ohio River. Located on the southern edge of Mason County, Ashton is near the area of the county known as Mercer's Bottom. One story told around the county explains that the village was named by Ella Belle Hill, who, after noticing the many ash trees in the area, commented that, "If you are going to have ashes, then make it a ton of them." (Courtesy of Point Pleasant Post Office.)

# www.arcadiapublishing.com

Discover books about the town where you grew up, the cities where your friends and families live, the town where your parents met, or even that retirement spot you've been dreaming about. Our Web site provides history lovers with exclusive deals, advanced notification about new titles, e-mail alerts of author events, and much more.

**MADE IN THE**

Arcadia Publishing, the leading local history publisher in the United States, is committed to making history accessible and meaningful through publishing books that celebrate and preserve the heritage of America's people and places. Consistent with our mission to preserve history on a local level, this book was printed in South Carolina on American-made paper and manufactured entirely in the United States.

This book carries the accredited Forest Stewardship Council (FSC) label and is printed on 100 percent FSC-certified paper. Products carrying the FSC label are independently certified to assure consumers that they come from forests that are managed to meet the social, economic, and ecological needs of present and future generations.

**FSC**
**Mixed Sources**
Product group from well-managed forests and other controlled sources

Cert no. SW-COC-001530
www.fsc.org
© 1996 Forest Stewardship Council

Find Your Place in History.